Gelli Arts
Printing Guide

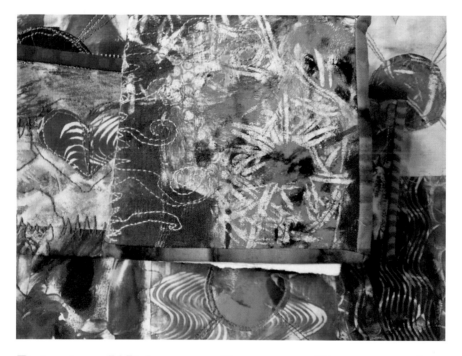

Printing Without a Press on Paper and
Fabric Using the Gelli Arts® Plate

SUZANNE MCNEILL

Suzanne McNeill

Suzanne is often known as "the Trendsetter" of arts and crafts. Dedicated to hands-on creativity, she constantly tests, experiments, and invents something new and fun. Artist, designer, author, and workshop instructor, Suzanne has spent a lifetime inspiring people to engage in artistic expression. Suzanne founded Design Originals, a publishing company dedicated to all things fun and creative. She is a designer, artist, columnist, TV personality, publisher, art instructor, author, and lover of everything hands-on. Visit her website, *SparksStudioArt.com*, to see events, books, and free YouTube demos.

ISBN 978-1-4972-0540-6

Gelli Arts® Printing Guide (2021) is a revised and expanded edition of *Gelli® Printing* (ISBN 978-1-57421-913-5), published by Design Originals in 2014. Revisions include a new gallery.

© 2014, 2021 by Suzanne McNeill and New Design Originals Corporation, *www.d-originals.com*, an imprint of Fox Chapel Publishing, 800-457-9112, 903 Square Street, Mount Joy, PA 17552.

Library of Congress Control Number: 2020950286

We are always looking for talented authors. To submit an idea, please send a brief inquiry to acquisitions@foxchapelpublishing.com.

Printed in China
Third printing

Introduction

Printing with a gel plate is an intriguing process that results in beautiful, one-of-a-kind, hand-printed papers with amazing colors, textures, and layers. The materials are commonly available and acrylic paints are easy to use. It is simple to make monoprint artwork, colorful pages for art journals, greeting cards, fabric for quilting, and much more. The process is so-o-o much fun and the results are amazing. There is no way to "mess up"!

A gel plate is portable, making it easy to share your passion for creating exquisite papers with friends. Use it at home, take it to a workshop, or even take it outdoors.

Gel plate printing is an economical choice for beginning printmakers and students as well as anyone who just wants to try out the printing process. Just a warning, though—this art form can be addictive. Pull your first print, try another, add a layer, and soon you'll never want to stop!

In this book you'll learn the basics: information on supplies, how to get started, and the best techniques, like how to make colorful backgrounds, textured pages, multiple layers, basic borders, and masks. You'll see how to use assorted papers, stencils, found objects, texture tools, and stamps to create innovative, interesting, and practical works of art.

You'll also find inspiring projects created by talented guest artists. These projects and all the photos in this book are meant as inspiration for your own gel-printed papers and fabrics.

Once you get going, the ideas start flowing, and it's really hard to stop. Enjoy the process, and come join the fun!

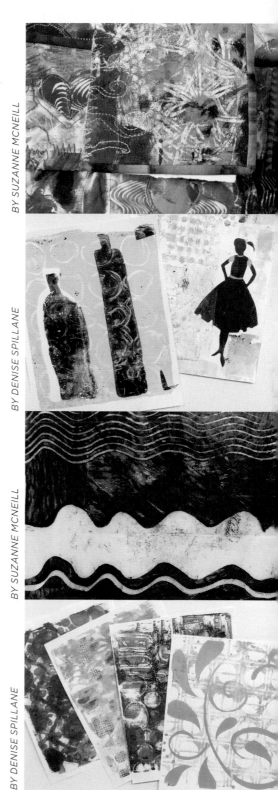

BY SUZANNE MCNEILL

BY DENISE SPILLANE

BY SUZANNE MCNEILL

BY DENISE SPILLANE

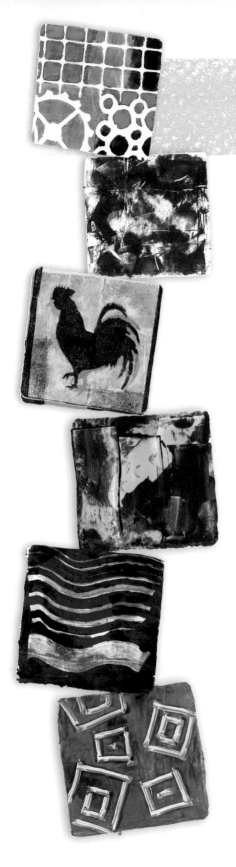

Table of Contents

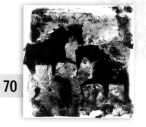

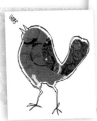

70

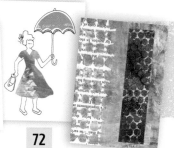

72

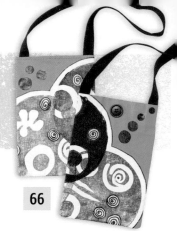

66

Projects

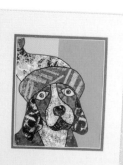

79

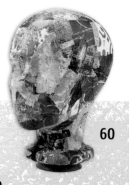

60

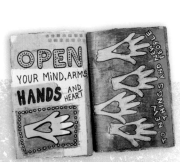

54

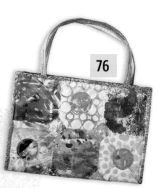

76

Gallery

On the following pages is a collection of beautiful art made by gel plate artists from around the world. Each artist shares a little peek into what motivates their art and why they love using gel printing techniques. Take inspiration from their work and enjoy exploring and developing your own unique artist style!

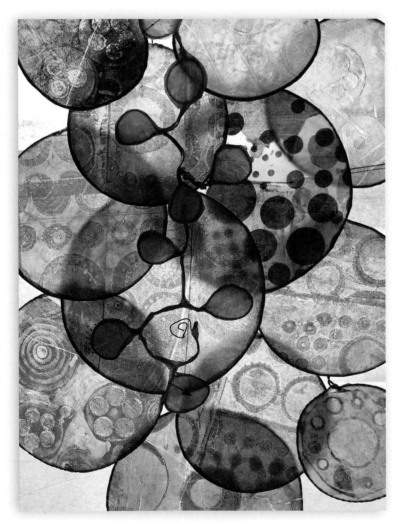

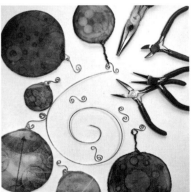

This tissue paper window installation was made with simple tools and wire to catch the light. "I love how the gel pad allows me to experiment with layers of textures and color on different materials," says artist Julie Anderson. (Julie Anderson, *www.juliejulie.co*)

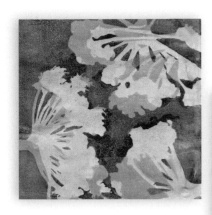

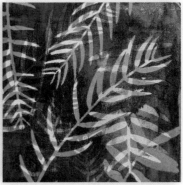

These pieces, titled "Summer's Silhouette" and "Memories of Perth, Australia," take strong inspiration from the natural world. Artist Jo Atherton says, "The versatility of a gel plate means I am able to produce spontaneous monoprints and enjoy the excitement of a big reveal moment time after time." (Jo Atherton, *www.joatherton.com*)

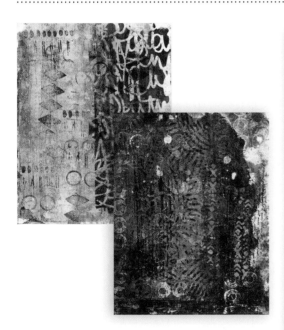

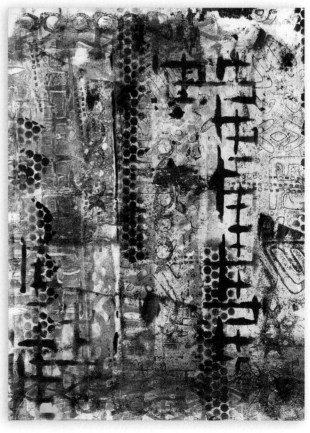

Artist Rachel Juanita Bellamy says, "I love gel printing for the pure mystery and magic of each pull and the uniqueness of every print. I gel print in layers and segments, so I never know how a piece will turn out. I'm forced to trust the process and enjoy the magic." (Rachel Juanita Bellamy, *www.soulreign.com*)

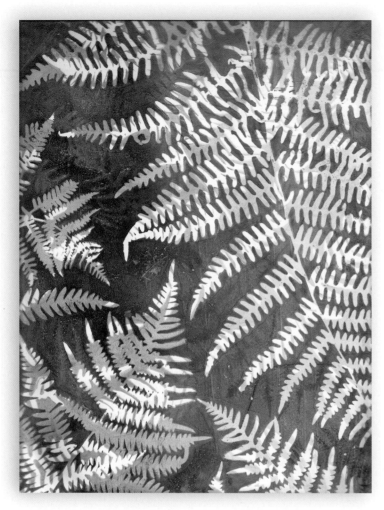

Artist Jennifer Douglas takes a lot of inspiration from nature around her home in Somerset, England. She says, "I find the process of gel printing so intriguing. It can easily capture the delicate patterns and shapes of leaves, but with a little experimentation it can offer endless possibilities of almost magical effects, like dappled light and hidden shadows observed from woodlands, hedgerows, and my wild garden." (Jennifer Douglas, *https://jennifer-douglas.com*)

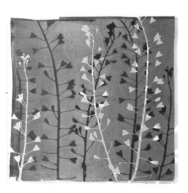

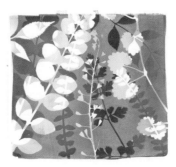

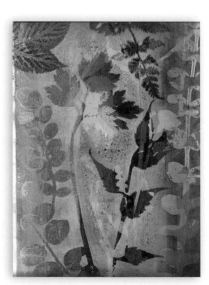

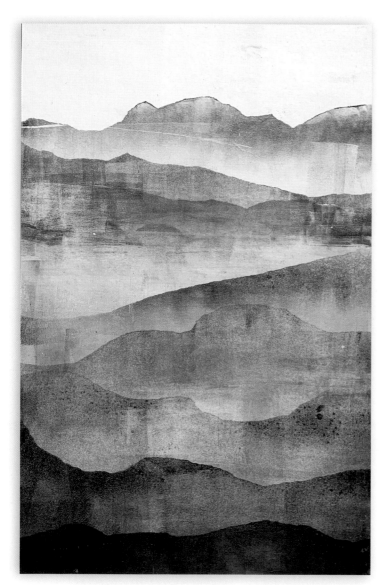

Kim Herringe likes to use her gel plate and botanical findings from her garden to recreate moments of relief that she finds in the natural environment. She says, "This process, for me, comes with an approach where there is no such thing as a mistake. I like to release the attachment to the outcome, enjoying each step of the process in a playful and mindful way, 'feeling' my way through each print." (Kim Herringe, *https://kimherringe.com.au*)

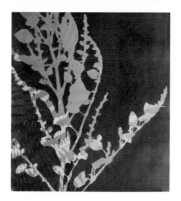
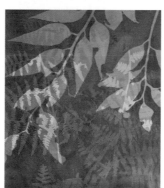
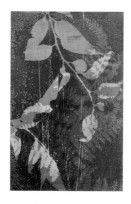

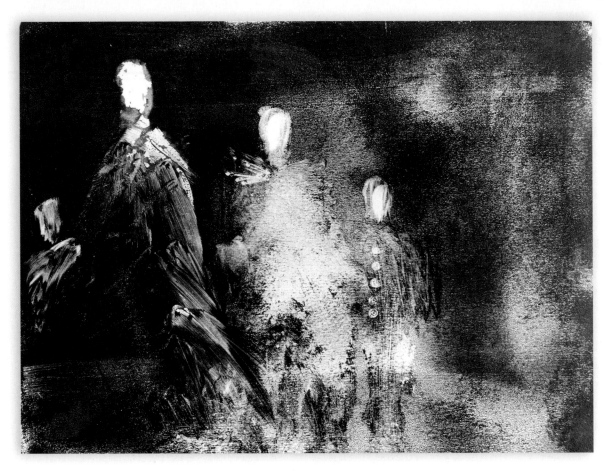

This dark, moody piece, titled "Family Portrait," shows how you don't need a lot of color to create a strong impact in gel printing. Artist Sally Muir says, "I like working with gel printing, as it's very tactile, both the actual gel plate and how you can work with it. I generally use my fingers with or without a rag—it's messy, but enjoyably unpredictable." (Sally Muir, *www.sallymuir.co.uk*)

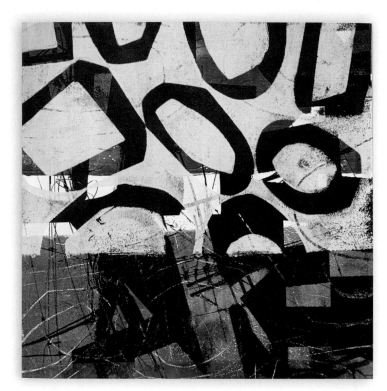

Drew Steinbrecher, the artist of this piece titled "That One Time in Queens," says, "My art is inspired by urban environments, and a gel plate allows me to replicate the grittiness of urban elements, such as crumbling concrete, walls with torn posters, and old billboards." (Drew Steinbrecher, *www.andrewsteinbrecher.com*)

What do you see when you look at this painting? A gel plate can be a great tool for making abstract pieces that are up for interpretation. Artist Ellen Rolli says that using a gel plate "adds an exciting and spontaneous element to my intuitive abstracted painting process." (Ellen Rolli, Instagram: @ellenrolli)

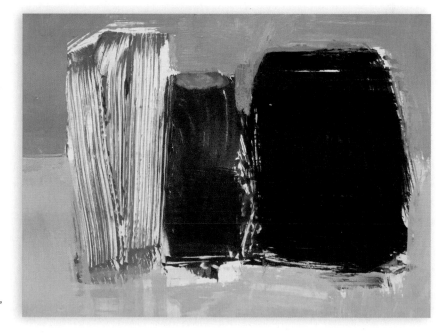

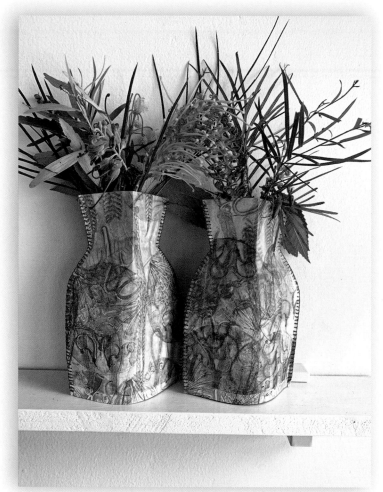

Artist Tara Axford considers her gel plate to be one of the most versatile tools in her studio. She loves how it allows her to get "a quick printmaking fix, without a huge setup!" Sometimes she takes her work to the next level by transforming it into 3D objects, like these stitched flower vases. (Tara Axford, *www.taraaxford.com*)

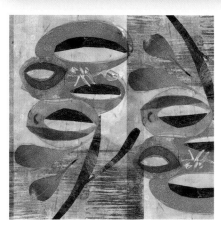

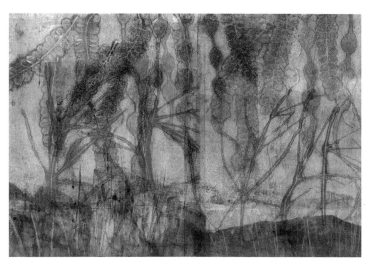

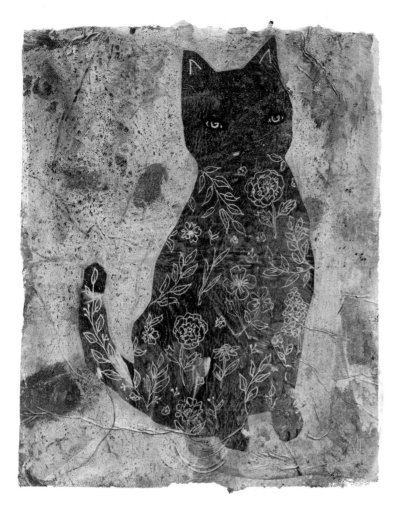

Idania Salcido's series of cat prints shows just how adorable and versatile a single motif can be. She says, "I fell in love with the fact that you can print things! The possibilities are endless once you get the idea, and you can make an infinite number of variations with the same pattern, just by changing the inks and colors you use." (Idania Salcido, *www.danitaart.com*)

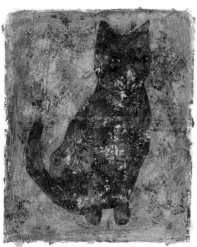
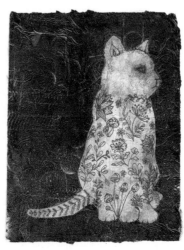
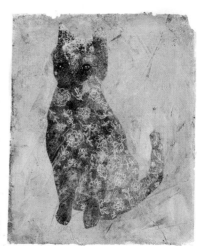

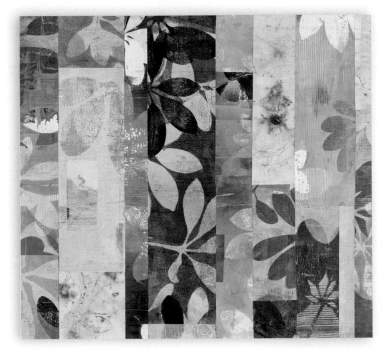

This bright colorblock design, called "Sunshine and Umbrellas 2," shows how structure and straight lines can play well with vibrant color and organic shapes. Artist Hannah Klaus Hunter loves that she has found "a medium with the nuances of a printing press without the press." (Hannah Klaus Hunter, *https://hannahklaushunterarts.com*)

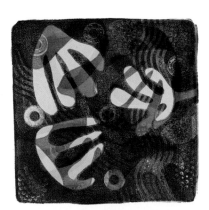

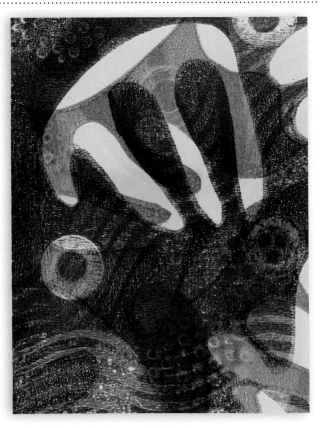

This piece, called "Layered Organic Shapes," seems to pop out at the viewer almost like you're wearing 3D glasses. Creator Amanda M. O'Shaughnessy loves working with the gel plate in part because "the artworks are always so exciting to reveal!" (Amanda M. O'Shaughnessy, *www.TheStudioArtClub.com*)

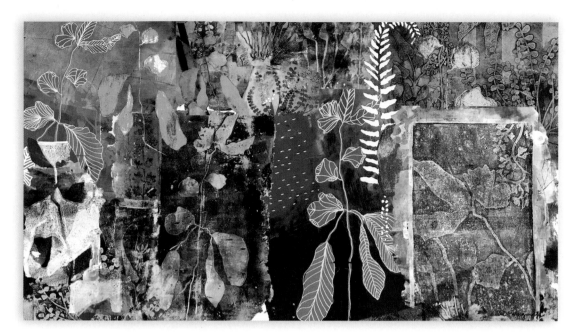

Titled "Rooted," this marvelous piece is a riot of color and texture that feels like a celebration of both the natural world and the medium used to create the art. "There is something exciting about the images that appear when working with a gel plate. I love how the paint and marks of the previous prints intermingle with newer layers to create unexpected magic with each pull of the substrate," says artist Rae Missigman. "My favorite element of printing is the unknown. No matter how well you plan for a print, something unexpected always surfaces and adds its own signature to the print." (Rae Missigman, *www.raemissigman.com*)

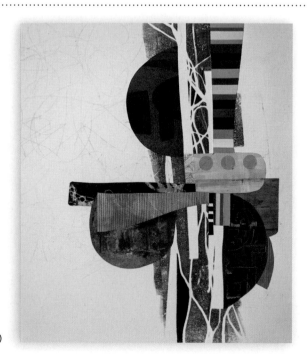

This abstract piece, titled "Vertical Sailing," springs from the clean white background to intrigue the eye. "For me, gel printing is the perfect way to create prints that are equally complex and alive," says artist Simone Sass. "I love how I can use these prints in so many ways, e.g., for my collages or as single pages in self-made books and art journals." (Simone Sass, *www.simonesass.com*)

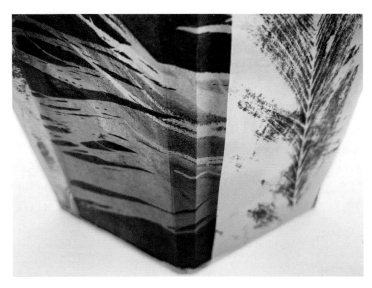
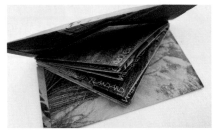
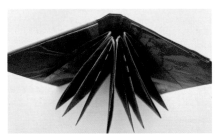

Artist Sinéad Lawson creates beautiful miniature art books using her gel plate, such as a book inspired by the poem "'Hope' is the thing with feathers" by Emily Dickinson, as well as a book that captures a memory of summer. Both booklets feature an accordion-style fold, but structured differently. "I adore working with a gel plate because of the ease and simplicity when using it but yet the ability to capture and print the finest of details," she says. (Sinéad Lawson, Instagram: @airyfairyletters)

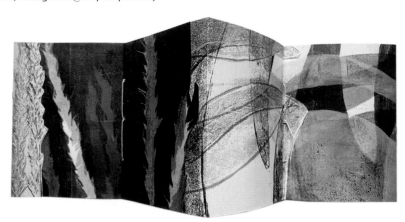

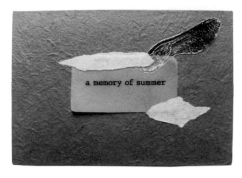

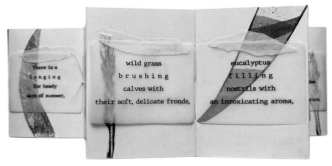

a memory of summer

There is a
longing
for heady
days of summer.

wild grass
brushing
calves with
their soft, delicate fronds,

eucalyptus
filling
nostrils with
an intoxicating aroma,

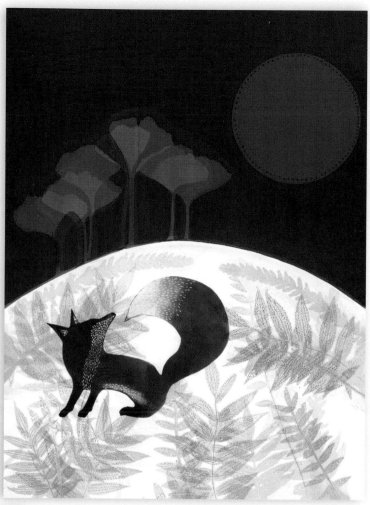

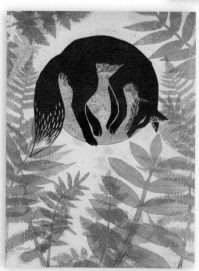

Lucy Brydon's works shown here, titled "The Fox and the Copse" and "Fox and Moon," mix areas of dense texture and solid color for a lovely contrast. "I am especially drawn to animals such as foxes and hares," she says. "I love the transparent layers that I can achieve to build up this kind of whimsical, illustrative image." (Lucy Brydon, *https://lucysartlab.com*)

Techniques for Gel Printing

Basic Supplies

The gel plate is a revolutionary surface for printing. It is durable and reusable. The plate is flexible and easy to clean with water, so you can quickly change paint colors and move right to your next project or print.

Print on almost any paper: printmaking paper, mixed media, cardstock, 140# watercolor paper, deli paper, book pages, and sheet music are all suitable.

The basic supplies you will need include a gel plate, a soft rubber brayer, and a plastic card. A permanent Gelli Arts® plate works well, or you can make your own gel plate; see pages 21-22 for recipes.

Acrylic paints offer many color choices in soft body, heavy body, fluid acrylics, craft acrylics, and open acrylics. Acrylics dry quickly. You can also use Speedball® or Akua™ printing ink. All work well. Experiment to find the ones you like best.

You will also need a few general supplies: old newspapers, freezer paper (or palette paper), paper towels, baby wipes, vinyl gloves, masking tape, and a cup of water.

CARE OF GEL PLATE AND BRAYER: Do not let the gel plate sit on a rough or porous surface or it may pick up textures or stick to the surface. Set the gel plate on the shiny side of freezer paper, on a smooth plastic surface, or on a nonstick craft sheet.

CLEANUP: Blot the plate with scrap paper to remove excess paint, then clean it with a baby wipe or wet paper towel. Roll the brayer on scrap paper to remove excess paint, then clean it with a baby wipe or wet paper towel. Immerse the plate and brayer in slightly sudsy water and rub them with a sponge to clean off any residual paint.

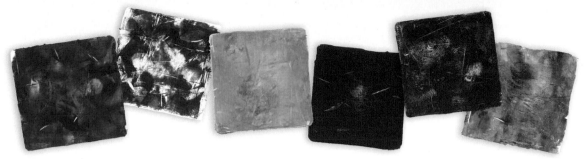

Basic Techniques

Printmaking is a free-form art. There is no right or wrong, and each print will be unique. Allow yourself to play with these steps and experiment. If you don't like a print, just set it aside and try another, or layer another color on top. Test color combinations and texture techniques. Treat this as a journey. There is an unexplored galaxy of possibilities out there waiting to be printed by your hand.

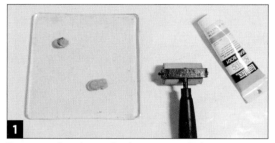

1 Squeeze a few drops of paint onto a gel plate.

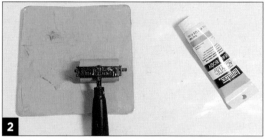

2 Use a brayer to roll out paint smoothly.

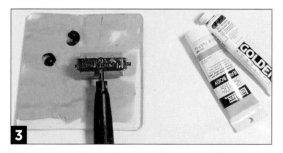

3 Squeeze a few drops of a second color onto the plate.

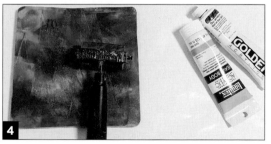

4 Use the brayer to roll out a smooth layer (a marbling effect is what you're going for).

5 Lay a piece of paper over the plate and smooth the paper with your palm. Gently pull the paper up from one corner to check the color.

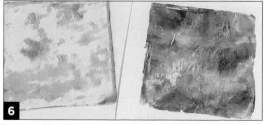

6 Finish pulling the paper all the way off. This is called "pulling the print."

Continued on next page

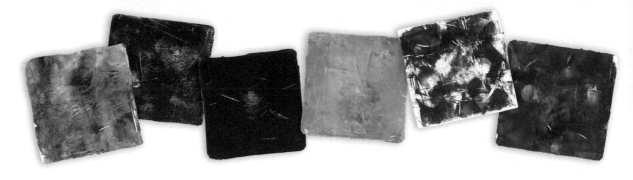

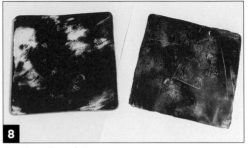

7 Roll out a few more color drops with the brayer. Lay another paper over it and pull up one corner to check the color.

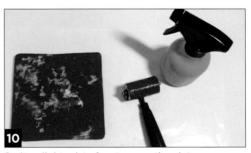

8 Gently pull a print.

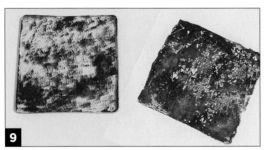

9 Pull a second "ghost" print, which is lighter, with a new sheet of paper.

10 Spritz a light mist of water over the plate.

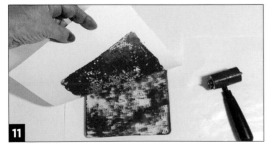

11 Pull another light ghost print. Continue this process until the plate is clean.

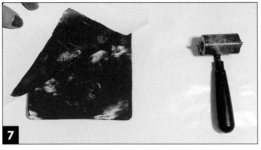

12 Clean the plate and brayer. A baby wipe works very well.

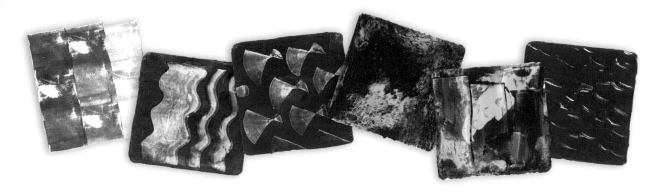

Recipes for Homemade Gel Plates

I love my purchased Gelli Arts printing plate. It is so handy to just store on the shelf and then grab and go whenever I am inspired to make prints. But for those of you who love to make your own materials, the gel plate recipes below work well. The temporary plate lasts about four weeks in the refrigerator. The permanent plate will last much longer.

You will need a nonporous pan or container that is at least 2" (5cm) deep. I recommend a handy acrylic box frame for a rectangular plate. I also recommend a firm, flat surface, such as acrylic (Plexiglas®), to carry the plate after you remove it from the mold.

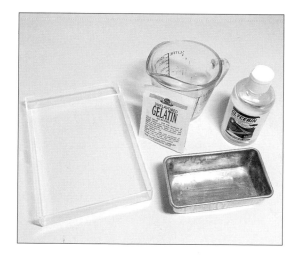

Temporary Plate Gelatin Recipe

lasts about four weeks in a refrigerator

MATERIALS: 12 packets Knox® gelatin (1 ounce [28g] each), 3 cups (0.7L) boiling water, 3 cups (0.7L) cold water, 1 tablespoon bleach

Mix gelatin with hot water and stir to dissolve. Add cold water and stir. Pour into mold. Be sure it is 1"–2" (2.5–5cm) thick in the pan. Push air bubbles to the edge of the mold. Refrigerate overnight. Run a knife around the edge to loosen. Remove from mold.

NOTE: If the plate becomes damaged, place the pieces in a microwave on high to melt, then pour the liquid into a mold and refrigerate overnight again to reset.

NOTE: The temporary plate may grow mold after a few weeks.

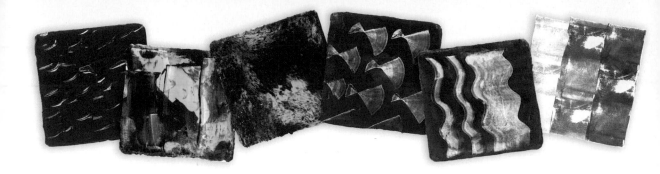

Permanent Plate Gelatin and Glycerin Recipe

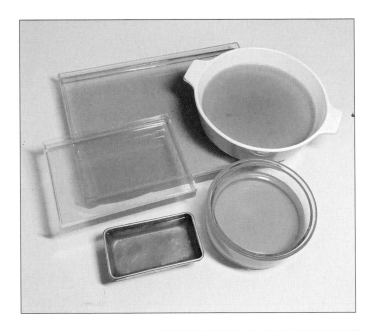

MATERIALS: 7 packets Knox gelatin (1 ounce [28g] each),
1½ cups (0.35L) glycerin, 1½ cups (0.35L) boiling water

Mix gelatin with glycerin and stir well. Slowly stir in boiling
water. Mix well. Pour into mold. Push air bubbles to the edge
of the mold. Let set overnight. Run a knife around the edge to
loosen. Remove from mold.

NOTE: It is best to carry and store the plate on a sturdy
nonstick surface such as a sheet of acrylic (Plexiglas) cut to
0.5" (1.5cm) larger than the plate on all sides.

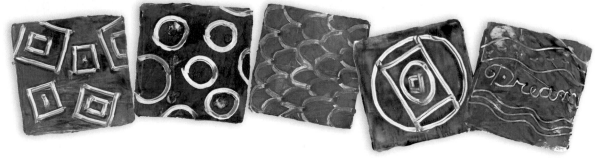

Making Marks with a Stick

You can make an amazing number of designs by simply using a stick. Create different textures with a rubber brush scraper or with a blunt stick like a chopstick. Use the samples shown here as fuel for your imagination.

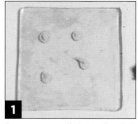

1 Squeeze small dots of paint onto a gel plate. Roll paint smooth with a brayer.

2 Squeeze small dots of a different paint color along the edges.

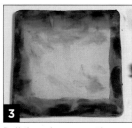

3 Roll the edges smooth with a brayer to create a border.

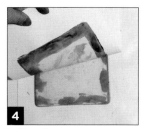

4 Pull a print.

Options

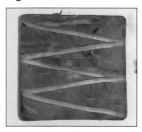

Draw a zigzag line.

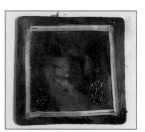

Draw a border with a chopstick or something similar.

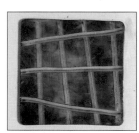

Draw a grid.

Draw boxes.

Draw circles.

Draw scallops.

Draw fun shapes.

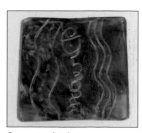

Draw squiggles.

Adding a Second Layer to Your Print

Monoprints are fun and interesting, but a second layer adds punch to your project. You can keep going, adding multiple layers, if you like.

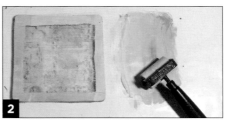

Make a red print. Let dry. Squeeze a few drops of yellow paint onto freezer paper. Roll the brayer on paint until smooth.

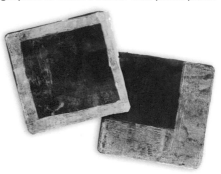

Roll the brayer around all four edges of a clean gel plate to create a border with yellow paint.

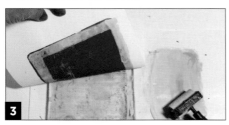

Lay the red print over the plate. Pull a print to reveal a yellow border on top of the red.

What to Do about Too Much Paint

One of the most common problems for beginners occurs when too much paint is squeezed onto the gel plate. When rolled out on the plate, the paint will look bumpy. To be thrifty, scrape off a bit of excess paint.

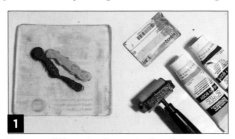

Squeeze different colors onto the plate.

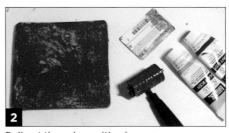

Roll out the colors with a brayer.

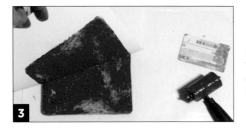

Pull a print. There is a pebbly surface from too much paint. Use a plastic card to scrape off excess paint; use this excess paint on the next print. Roll out paint with a brayer until smooth.

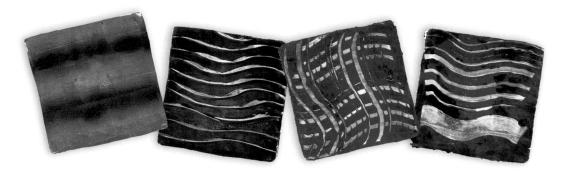

Making Marks with a Plastic Card

Trim the edge of an old plastic card, such as an expired credit card or gift card, to create interesting textures. Try fringe in varying widths as well as triangles in several sizes.

1 Prepare plastic cards by cutting fringe shapes into an edge. Cut the cards into wide and narrow strips.

2 Apply a few dots of color paint to the gel plate. Roll out a smooth, thin layer of paint with a brayer. Add more dots if desired.

3 Use the wide and narrow strips of plastic cards to draw stripes. Pull a print.

Options

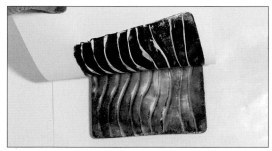

Use a plastic card with a shaped edge to create wavy lines. Pull a print.

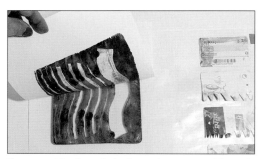

Use a combination of plastic cards to create thin and thick lines. Pull a print.

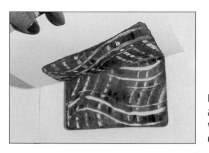

Use a plastic card with a shaped edge to create wavy lines in both directions. Pull a print.

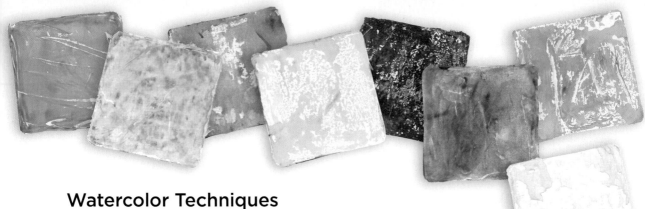

Watercolor Techniques

Be thrifty and make your paint last longer! This quick method works especially well when you are printing a solid color for the first layer.

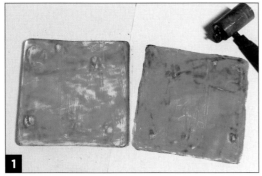

1 Apply a color of paint to a gel plate. Roll the paint smooth with a brayer. Pull a print.

Spray bottle of water

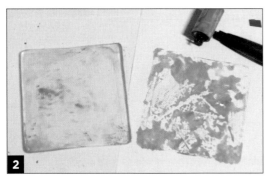

2 For a watercolor look, lightly mist the plate with water. Roll the brayer across it. Pull a "light" print.

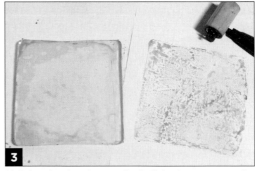

3 Lightly mist the plate again. Roll the brayer across it. Pull a light print. Repeat until no color remains.

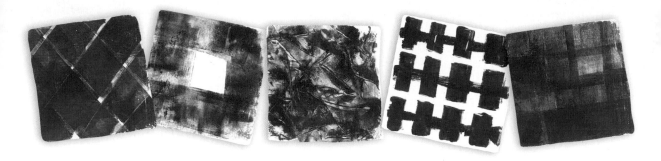

Making Textures with a Brayer

A brayer is a wonderful tool. Use it to roll paint smoothly, gradate colors, and add patterns and texture. To apply colors to the brayer, squeeze paint onto freezer paper and roll the brayer in the paint until it is covered smoothly. Then apply more color to the gel plate.

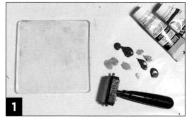

1 You'll need a gel plate, a 2" (5cm) soft rubber brayer, and dots of paint on freezer paper.

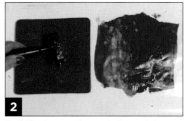

2 Roll the brayer through the paint on the freezer paper. Apply color to the plate.

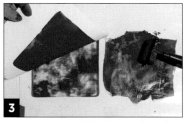

3 Create textures with a brayer by using it flat or tipping it on its edge. Pull a print.

Vertical stripes

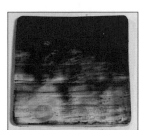

Horizontal stripes

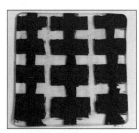

Bowties

Left and right

Diagonals

Border frame

Topsy-turvy

Checkerboard

Making Colorful Papers While Cleaning a Brayer

To be thrifty, I try to use all of my paint. To remove excess paint or change the color of paint, roll the brayer on deli paper, on newspaper, or on the pages of an art journal. Add a color border or strip to paper by simply rolling a brayer with the desired color of paint across the surface of the paper. Add the border around a section printed with a gel plate, or roll several rows or areas on the paper. If desired, the paper can be overprinted with stencils and textures.

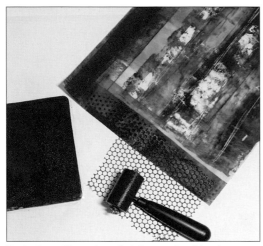

To start, you'll need a gel plate, a soft rubber brayer, acrylic paints, paper, and assorted textures, stencils, and objects.

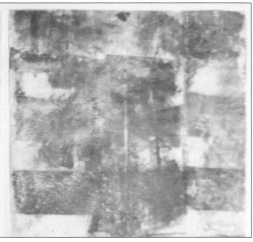

Roll brayer across the paper to make wide rows of color. Use brayer to make irregular patches of a different color on top.

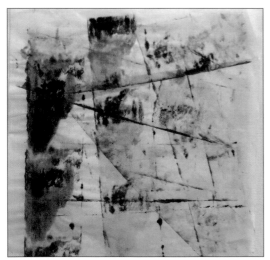

Roll brayer in irregular vertical stripes of color. Tip brayer on its edge to roll thin lines.

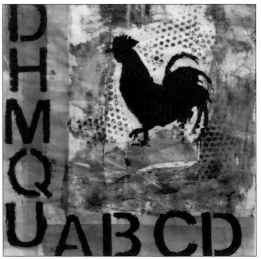

Roll brayer over paper with the first color. Roll brayer over stencils to create letters and shapes.

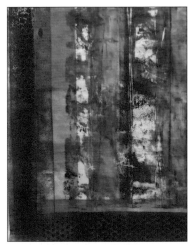

Roll brayer to make vertical stripes. Roll brayer to add borders on two sides.

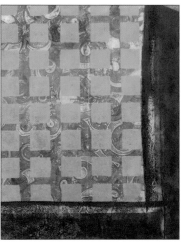

Print over a grid stencil to make a block. Roll brayer to make a frame and a border on the edges.

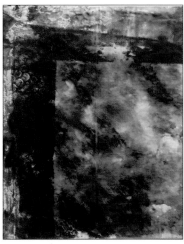

Print a large block with mottled colors. Use bubble wrap or another texture. Roll brayer to make a wide color border on two edges.

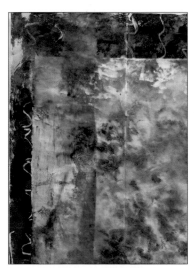

Print a large block with mottled colors. Roll brayer to make a wide color border on two sides.

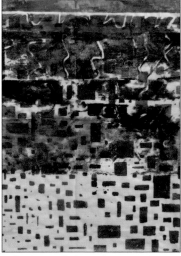

Roll a brayer in irregular rows of color. Roll brayer across a stencil with another color to make texture.

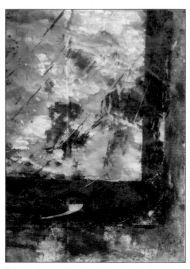

Print a large block with mottled colors. Roll brayer to make wide color borders on two sides.

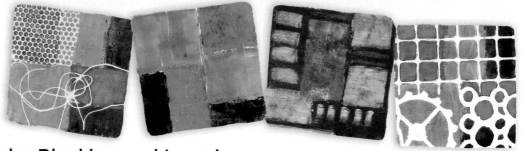

Color Blocking and Layering

The wonder of multiple-layer printing blooms as each layer influences both color and texture, developing into a surprising final print. I made several prints of the first layer of blocked colors to demonstrate different effects for layers two and three.

Getting Started

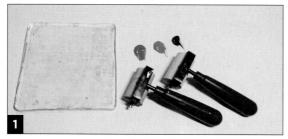

1 Use more than one brayer to save time and paint.

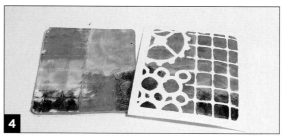

2 Roll color out on freezer paper to cover each brayer. Roll color onto a gel plate in blocks of color.

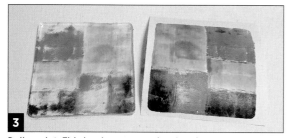

3 Pull a print. This is a layer one print. Let dry.

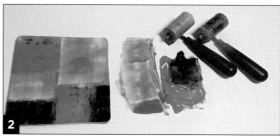

4 Or roll color onto plate, then add texture with stencils. Pull a print.

Layer Two: Stencil Textures

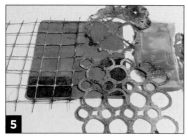

5 Position assorted stencils on top to create designs.

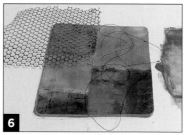

6 Or position assorted physical textures on top, like Punchinella and string, to create different looks.

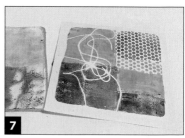

7 Pull a textured print on top of a layer one color block print.

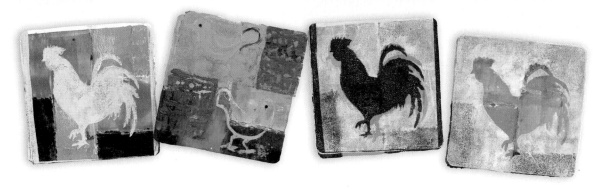

Layer Two: Stamped Textures

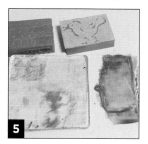

5 Roll paint onto a memory stamp (page 45).

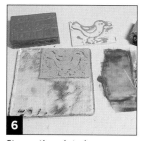

6 Stamp the plate in upper right corner. Roll paint onto a hot glue stamp (page 45).

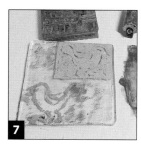

7 Print hot glue stamp on the plate in lower left corner.

8 Pull a print.

Layer Two: Mask and Stencil

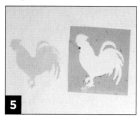

5 Use a stencil and/or a mask to print an image.

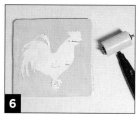

6 Roll paint onto a plate. Position a mask on top to create an image. Pull a print.

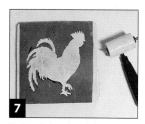

7 Roll paint onto plate. Position a stencil on top to create an image. Pull a print.

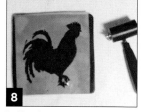

8 Roll paint onto plate. Position a matching mask on top of stencil image. Pull a print.

Layer Two: Marks

5 Roll paint onto the plate. Mark texture on the plate with a stick.

6 Pull a solid print on top of a layer one print.

Layer Three: On Top of Color

7 Roll blocks of paint onto the plate with a brayer. Add smaller blocks with a brush.

8 Pull a blocked print on top of a solid layer two print.

How to Change Colors on a Gel Plate

There is no need to clean a gel plate after each print. Change or add color with each print. Some of the previous layers of color will peek through to create unexpected dots, lines, and marks on the new printed layers or colors.

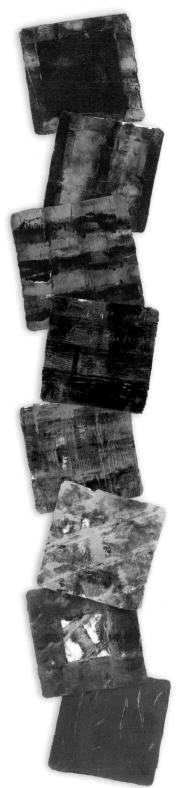

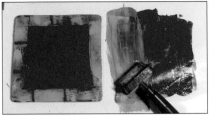

Frame: Roll out color on a gel plate. Roll a second color around the edges. Pull a print.

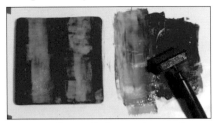

Vertical columns: Roll out columns of a color. Roll columns of a second color. Pull a print.

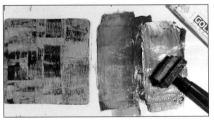

Add a third color: Roll out rows of a color. Roll out a second color to make rows. Add a third color in spotches or rows. Pull a print.

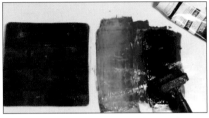

Add a fourth color: Lightly roll over the plate to create an irregular surface with a new color on top of the other colors. Pull a print.

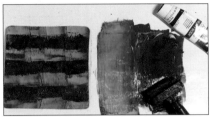

Add a fifth color: Roll another color over the plate, letting some of the colors beneath peek through. Pull a print.

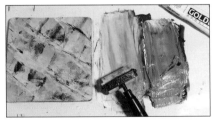

Add a sixth color: Roll another color over the plate in diagonal stripes. Pull a print.

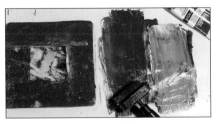

Add more of the first color: Roll out color on the plate in a square shape. Pull a print.

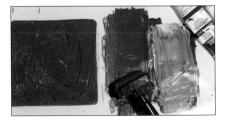

Wavy color: Roll out color on the plate. Make wavy marks with the edge of the brayer. Pull a print.

Printing on Black

If you want your artwork to really be showy, print the colors on a black background. Black makes colors dazzle and metallics sparkle.

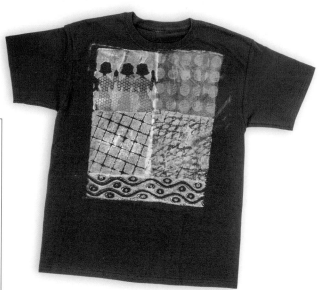

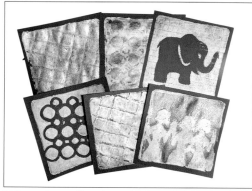

Iridescent metallic colors of paints are really showy on black.

Dazzle your friends with glitzy designs printed on your favorite black shirt.

You can choose any black paper or black cotton fabric.

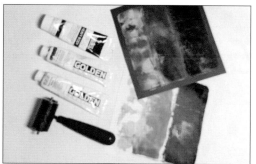

Transparent colors of paint are not very showy.

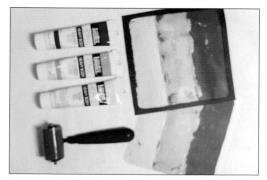

Opaque colors of paint (especially light colors) really pop.

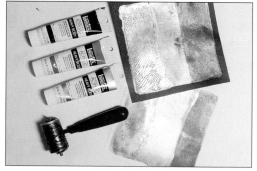

Metallic, iridescent colors of paint work great on black and include silver, gold, copper, and bronze.

Found Objects for Textures

Ordinary objects make really interesting designs. Just look around—you'll begin to see your world in a creative light. Expand your search for textures to the kitchen, sewing room, toy room, laundry room, and garage. All manner of things from paper clips to washers transform your prints into extraordinary art. Pictured are some ideas to get you started.

Wooden ruler

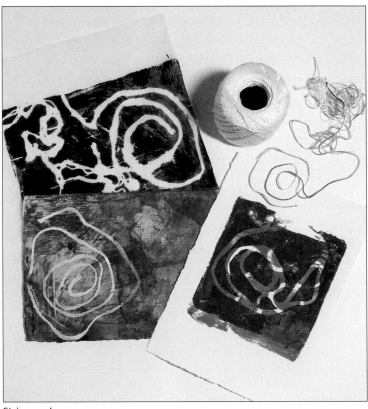

String and yarn

Combs and comb tools

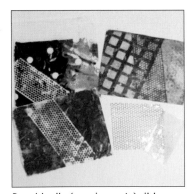

Punchinella (sequin waste) ribbon

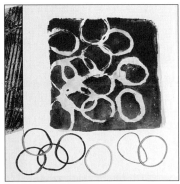

Rubber bands and hair ties

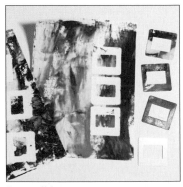

Paper slide mounts

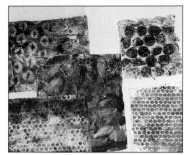

Bubble wrap (large or small)

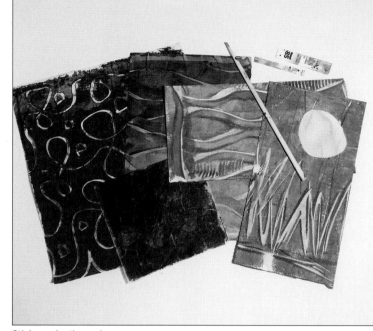

Stick or plastic card

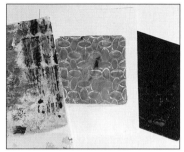

Rubber hot pad

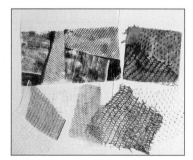

Fruit and vegetable mesh bags

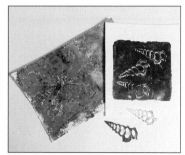

Sliced seashells

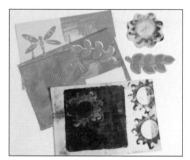

Foam and rubber stamps

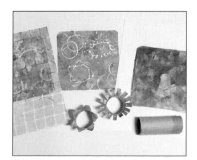

Toilet paper rolls cut into flowers and fringe

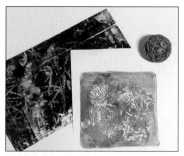

Rubber band ball

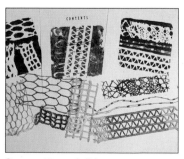

Open patterned ribbons

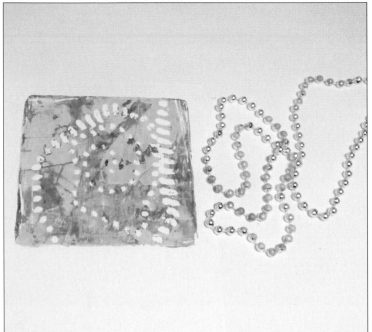

Ball bead necklace

Cookie cutters

2" (5cm) piece of swimming pool noodle

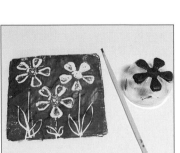

Felt or foam die-cut snowflake

Toy cars with wheel treads

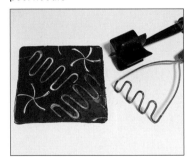

Potato masher and kitchen tools

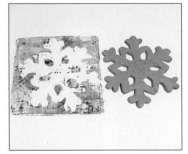

Bottom of a water bottle

Spiral notebook binding

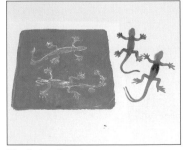

Plastic toy lizards

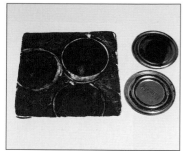

Tin can lids

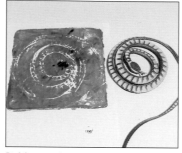

Rubber snake

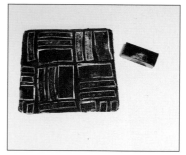

1" x 2" (2.5 x 5cm) magic eraser

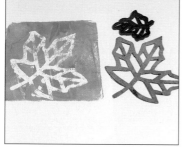

Felt shapes

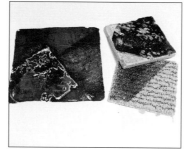

Tile and carpet samples

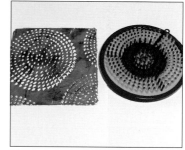

Plastic toy target

Metal owl trivet

Paint key and corrugated cardboard

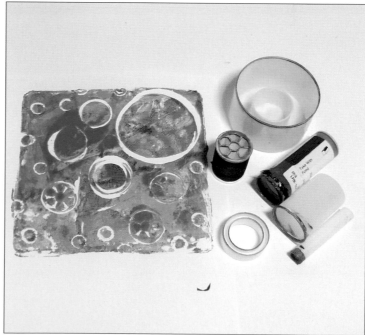

Thread spool, round containers, and lids

Stencils as Textures and Images

Stencils and die cuts are available everywhere. They come with wonderful patterns and images. The stencil technique is great for adding textures. You can also use stencils for printing to entertain children, who love to use them.

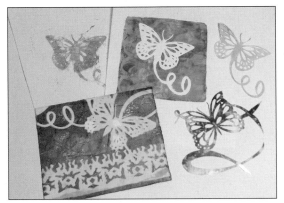

Plastic butterfly stencil (The Crafter's Touch)

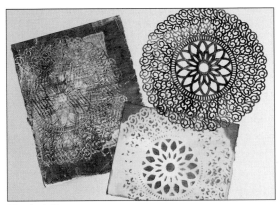

Plastic doily

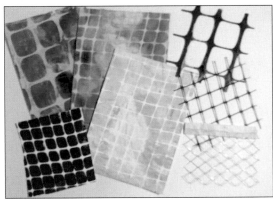

Plastic fencing

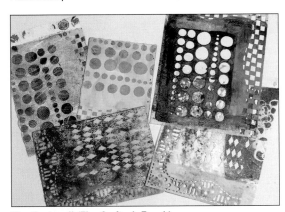

Plastic stencil (The Crafter's Touch)

Plastic stencil (TSW for Teachers)

Plastic stencil (The Crafter's Touch)

Plastic stencil (The Crafter's Touch)

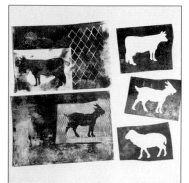
Plastic stencil (Crafts, Etc.)

Plastic stencil (The Crafter's Touch)

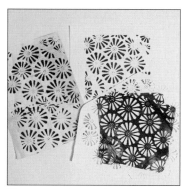
Die-cut greeting card (Martha Stewart)

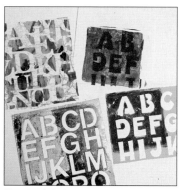
Plastic alphabet stencil (Crafts, Etc.)

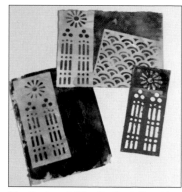
Plastic stencil (The Crafter's Touch)

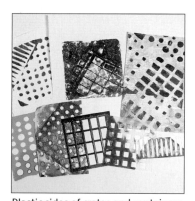
Plastic sides of crates and containers

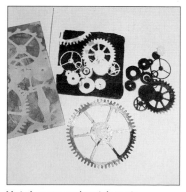
Metal gears and watch parts

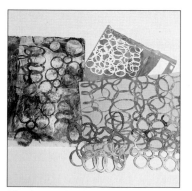
Plastic stencil (The Crafter's Touch)

Nature as Stencils and Masks

A walk around your yard or neighborhood park will yield a handful— or basketful!—of fun elements to try. There are plenty of leaves, flowers, grasses, and feathers out there just waiting for you.

Collect various shapes of leaves, grass, feathers, and twigs. You can also use plastic flower petals and leaves.

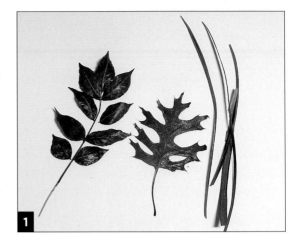

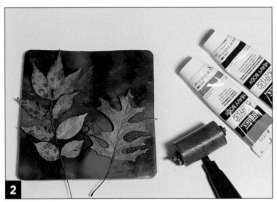

Position leaves on top. Roll paint onto a gel plate.

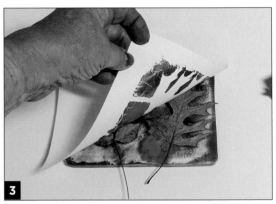

Press a piece of paper onto the plate. Pull a print.

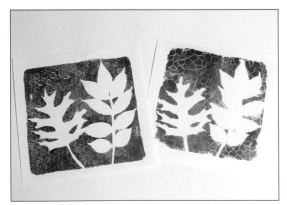

Negative Prints: Leave the leaf or shape on the plate when printing. Lay paper over leaves and press with your hand. Pull a print.

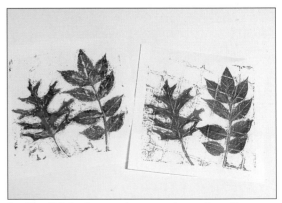

Positive Prints: Remove leaves or shapes from the plate to print. Lay paper over leaves and press with your hand. Pull a print.

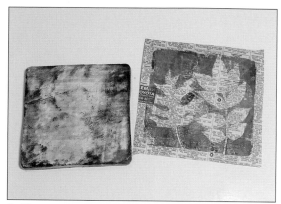

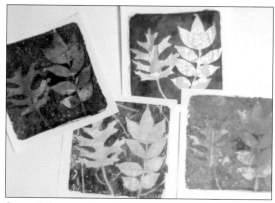

On Newspaper: Try printing nature images onto newspaper, discarded book pages, illustrated pages, or sheet music.

Over a Color: Negative prints done over a layer of bright color brings spark to the images. Try different colors for different looks.

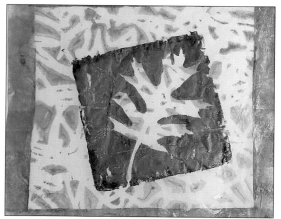

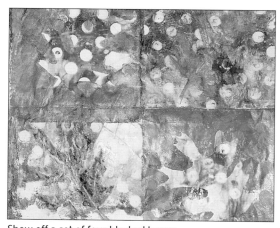

Use a negative leaf print in the middle as a focal point.

Show off a set of four blocked leaves.

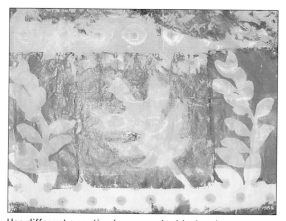

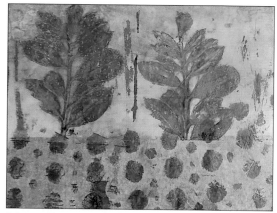

Use different negative leaves and add a border.

Print positive leaves; add a border if desired.

Make-It-Yourself Stencils and Masks

Stencil and mask shapes are a staple for gel printing. When you can't find a stencil or mask design that you like, or if you just want something totally unique, try these techniques to make your own.

Use a Tyvek® envelope, freezer paper, or cardstock.

Cut a shape to make a negative stencil and a positive mask.

Print a positive and negative shape.

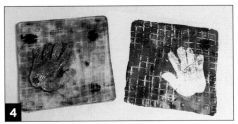

Here are some samples of positive and negative prints.

Make-It-Yourself Roller Stamps

Here's a recycling idea that saves money. Turn the empty rolls from bath tissue and paper towels into texture tools.

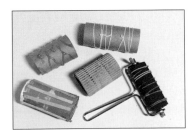

Cover cardboard rolls with string, hot glue drips, coffee stir sticks, and craft foam strips. If you have the type of brayer that will snap out of its handle, remove the roller to wrap it with rubber bands, and then put it back together.

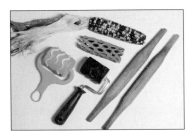

Additional textured rolls can be made from a corncob, a cactus branch, textured rolling pins, textured foam, and rubber brayers.

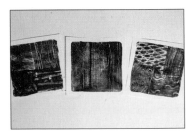

Here are some samples of roller stamp textures printed with a gel plate.

Sample Make-It-Yourself Stencils and Masks

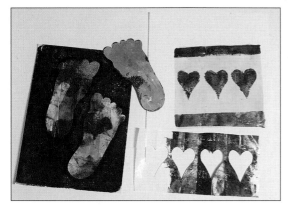

Footprint and hearts

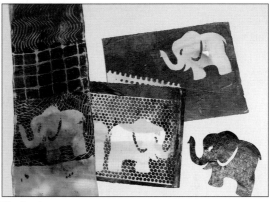

Elephants

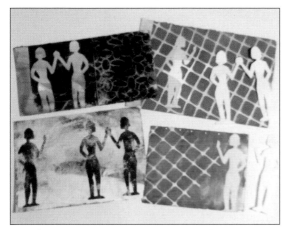

Friends

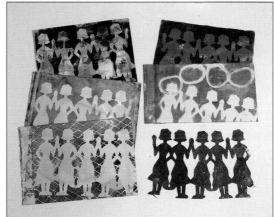

Paper dolls

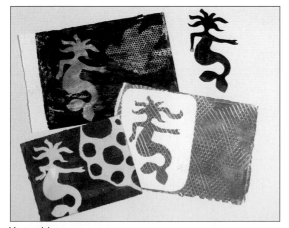

Mermaid

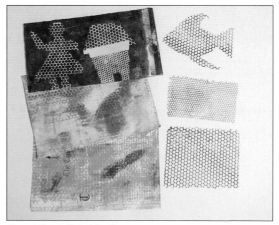

Shapes from Punchinella

Make-It-Yourself Stamp Designs

There are so many ways to make your own stamps. Sticky-backed craft foam is a great material for creating your own stamp designs. Flat pieces of metal and cardboard shapes are also good candidates.

1 You'll need sticky-backed craft foam for the design. Use pieces of cardboard for the backing.

2 Cut craft foam into various shapes. Stick the foam shapes to a piece of cardboard backing.

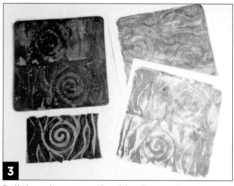

3 Roll the edges smooth with a brayer to create a border.

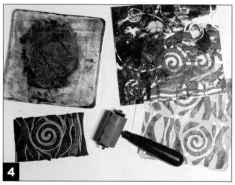

4 Roll out paint onto a gel plate. Stamp a foam design on the paint to create a texture.

Sample Make-It-Yourself Stamp Designs

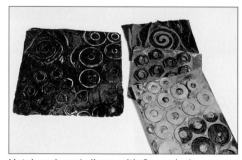

Metal washers (adhere with Goop glue)

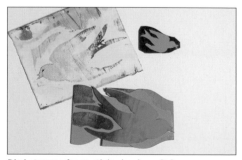

Bird stamps from sticky back craft foam

Make-It-Yourself Hot Glue and Memory Foam Stamps

Have you ever noticed how hot glue dries into a hard, raised line? Now, think stamps—and voilà, you can turn any simple line drawing into a stamp in the size you want.

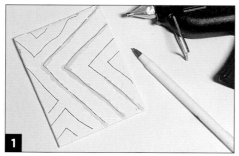

1 Use a pencil to draw a design on cardboard or foamcore board. Slowly go over the lines with hot glue to form a raised design.

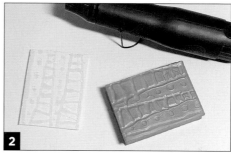

2 Use a heat gun to heat the surface of a block of memory foam. Firmly press the hot glue design (once it has dried) onto the memory foam to make an impression.

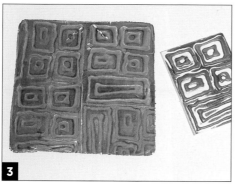

3 Roll out paint onto a gel plate. Stamp a foam design on the paint to create texture. Pull a print.

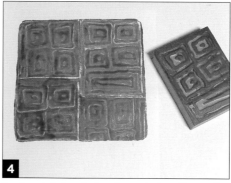

4 Apply paint directly to a foam design. Stamp the image directly on paper, over a dry gel print.

Sample Make-It-Yourself Stamp Designs

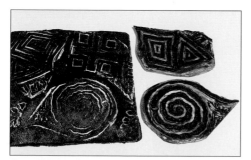

Carved stamp designs from stamp material

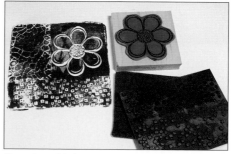

Store-bought stamps

Layering Colors and Textures

It is fun to play with colors and textures. I enjoy seeing what emerges with the layers. Happy surprises arise by experimenting. Try several combinations. Here are a few to inspire you.

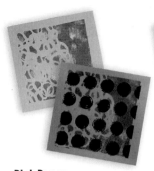 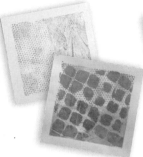 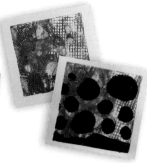 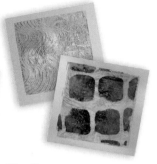

Pink Paper
Layer 1: Darker Pink
Layer 2: Purple

Yellow Paper
Layer 1: Light Green
Layer 2: Dark Green

White Paper
Layer 1: Purple
Layer 2: Dark Purple

Blue Paper
Layer 1: Medium Blue
Layer 2: Dark Blue

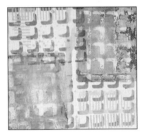

by Carolyn Skei

by Suzanne McNeill

by Denise Spillane
(Stencil Girl Club)

by Paula Pillow

 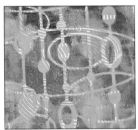 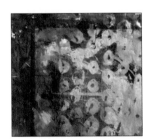

by Denise Spillane
(I Stencil)

by Denise Spillane

by Cindy Shepard
(The Crafter's Touch)

by Suzanne McNeill

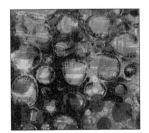 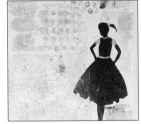 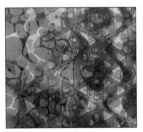 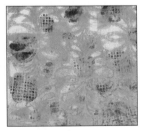

by Denise Spillane (Stencil
Girl Club and I Stencil)

by Denise Spillane

by Denise Spillane
(I Stencil)

by Denise Spillane
(I Stencil)

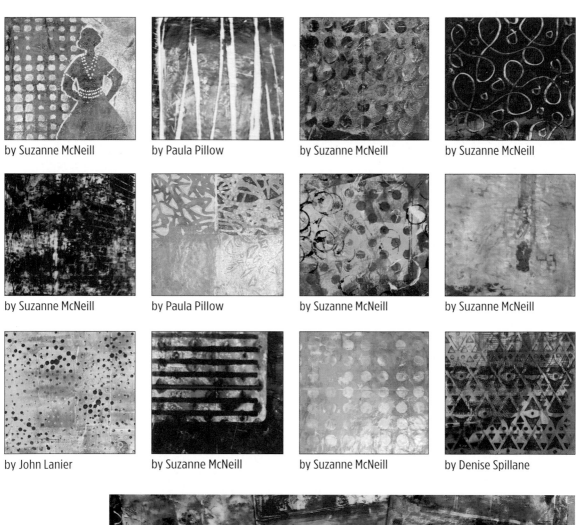

by Suzanne McNeill

by Paula Pillow

by Suzanne McNeill

by Suzanne McNeill

by Suzanne McNeill

by Paula Pillow

by Suzanne McNeill

by Suzanne McNeill

by John Lanier

by Suzanne McNeill

by Suzanne McNeill

by Denise Spillane

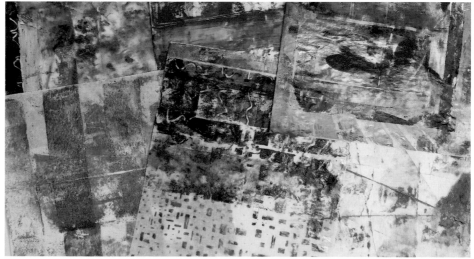

How to Line Up Layers

Line up layers of printing with this simple technique. Create beautiful multidimensional effects by layering. It's easy to do.

1 Cut a register frame from cardstock or Tyvek. Make the opening smaller than your gel plate.

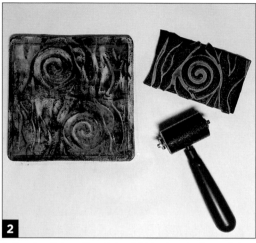

2 Roll out paint on the plate. Add texture to the paint with a stamp, stencil, or other technique.

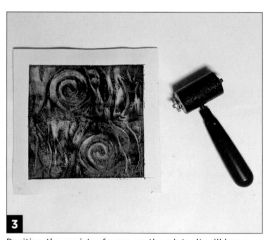

3 Position the register frame on the plate. It will hang over the edges of the plate.

4 Position your paper over the plate. Align the upper left corner of the paper and register frame.

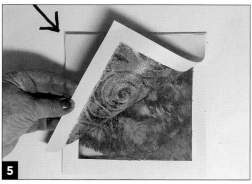

5 Pull a print.

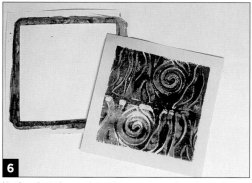

6 Notice that the register frame created a crisp edge around the paper print. Let dry.

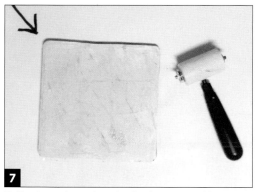

7 Roll out another color of paint for a second layer.

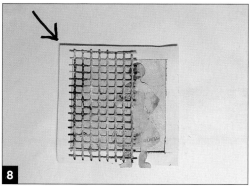

8 Position the register frame first. Add texture with a grid stencil, mask, or other technique.

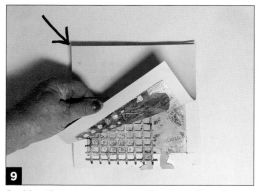

9 Position the same paper over the plate. Align the upper left corner. Pull a second print.

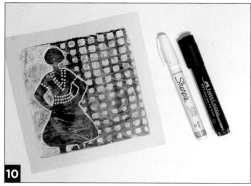

10 If desired, add additional layers of texture and images. Let the piece dry. Add lines and details with paint pens.

Projects

Image Collage on Canvas

BY SUZANNE MCNEILL

Create awesome effects when you use colorful printed deli papers to color images. Creative opportunities abound. Whether you give your images a lifelike appearance or go for a whimsical look, you are sure to enjoy this easy technique. This is a great way to use up small scraps, too.

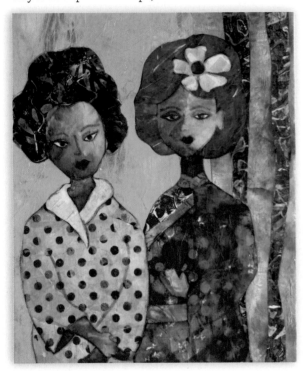

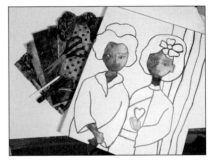

MATERIALS: 12" x 16" (30.5 x 40.5cm) stretched canvas, several colors of printed deli papers, tracing paper, scissors, pencil, large black permanent marker, adhesive acrylic medium (such as Soft Gel Gloss).

1. Select colorful papers printed on deli paper.
2. Use a pencil to draw an image with large, open areas on canvas. Go over the lines with a black permanent marker.
3. Lay a piece of printed deli paper over an area and trace the outline onto the paper with a pencil. Cut out the shape. **Note:** You can see through light-colored printed papers to trace the shape. For dark-colored papers, trace the shape on tissue paper and use this as a pattern to cut out the shapes.
4. Cover a shape on the canvas with adhesive acrylic medium. Lay deli paper on top, then gently pat and rub until smooth. Remove excess adhesive. Let dry.
5. Repeat with additional pieces of printed deli paper. Draw details such as facial features with the black marker.

Black Metallic Quilt

BY SUZANNE MCNEILL

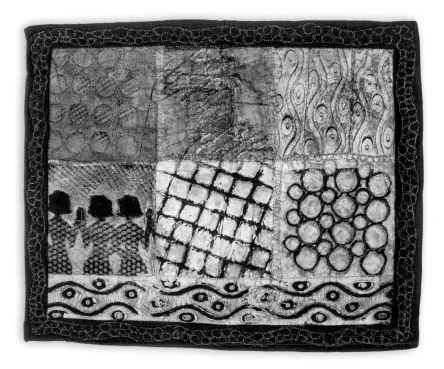

FINISHED SIZE: 16" x 19" (40.5 x 48.5CM)

MATERIALS: 1 yard (1m) black cotton fabric for quilt top, backing, binding, 16" x 19" (40.5 x 48.5cm) lightweight batting, Aurifil™ iridescent black thread for quilting, soft rubber brayer, stencils, sewing machine, fabric painting medium (such as GAC 900), iridescent acrylic paint (gold, silver, bronze, and copper).

Use a single piece of black fabric to make this sparkling art quilt. Lay a stencil over the paint on a gel plate to create texture. Each block was made with a gel plate. Carefully align and lay fabric over the plate, press, and lift to pull the print. Let each block dry before proceeding to the next square. Roll the bottom colored border onto fabric with a brayer. To assemble the quilt, layer backing, batting, and quilt top. Quilt with metallic thread. Add binding.

TIP: When working with gel prints on deli paper (as for the Image Collage on Canvas project, facing page), make a variety of styles in each color family so you build a stash from which to create other projects. Don't forget to include some stripes, dots, and large-scale, small-scale, mottled, geometrical, and whimsical shapes.

Block-by-Block Collage on Canvas

BY SUZANNE MCNEILL

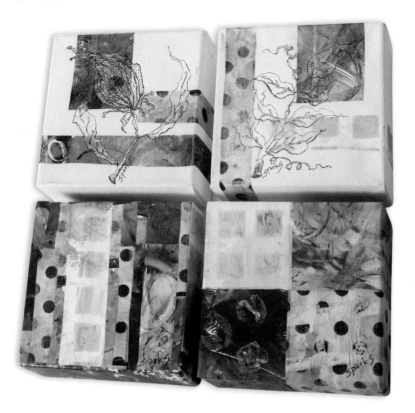

Capture the look of an art gallery with groupings of small canvases that show off your unique style and creative talents. As the "artist in residence," you can choose colors that complement your space and images that send the message you wish to convey.

MATERIALS: 6" x 6" (15 x 15cm) stretched canvas, scissors, four printed deli papers, adhesive acrylic medium (such as Soft Gel Gloss). Optional: To add an image, you will need tissue paper and a black permanent pen.

1. Select four coordinating prints that have been printed on deli paper.
2. Cut pieces of printed deli paper into the desired shapes.
3. Cover an area on the canvas with adhesive acrylic medium. Lay deli paper on top, then gently pat and rub until smooth. Remove excess medium. Let dry.
4. Repeat with additional pieces of printed deli paper.

OPTIONAL: Draw an image on tissue paper with a black pen. Roughly cut out the tissue paper image and adhere to canvas with medium (the tissue paper will become almost invisible). Let dry.

Pamphlet Stitch

BY SUZANNE MCNEILL

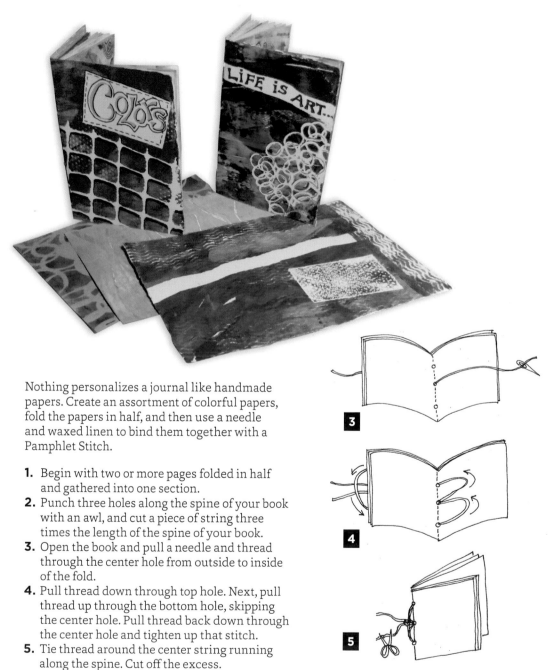

Nothing personalizes a journal like handmade papers. Create an assortment of colorful papers, fold the papers in half, and then use a needle and waxed linen to bind them together with a Pamphlet Stitch.

1. Begin with two or more pages folded in half and gathered into one section.
2. Punch three holes along the spine of your book with an awl, and cut a piece of string three times the length of the spine of your book.
3. Open the book and pull a needle and thread through the center hole from outside to inside of the fold.
4. Pull thread down through top hole. Next, pull thread up through the bottom hole, skipping the center hole. Pull thread back down through the center hole and tighten up that stitch.
5. Tie thread around the center string running along the spine. Cut off the excess.

Art Journals and Colorful Pages

BY SUZANNE MCNEILL

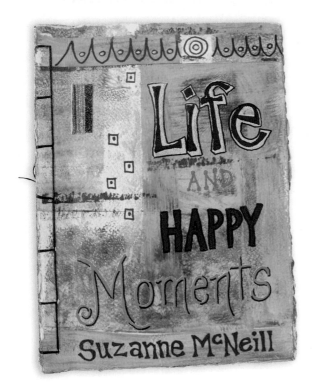

I love everything about art journals and creating my own papers and memories. Sometimes the journal is about a specific subject, idea, or inspiration. When I made the "Happy Moments" journal (featured), I went to a happy place for imagination, then poured my thoughts onto the pages. I'm sharing my art journals in hopes that they will inspire you to explore your joy and feel free to do what you love.

..

MATERIALS: 8" x 11" (20.5 x 28cm) printed designs on 140# watercolor paper or cardstock, scissors, pencil, colors of large paint pen markers, clippings of images and words from magazines, large needle, waxed linen thread, adhesive acrylic medium (such as Soft Gel Gloss).

..

1. Select colorful papers that have been printed on watercolor paper or cardstock.
2. As a reference and as collage fodder, clip magazine images and words of the sentiments you wish to express. Add meaningful quotes and great ideas.
3. Adhere an image or word on a page with adhesive acrylic medium. Pat and rub until smooth. Remove excess medium. Let dry.
4. Draw words and images with colored paint pen markers. Let the paint dry.
5. Stitch together with a Stab Binding (see facing page).

Instructions for a Stab Binding

1. Make a stack of papers that are printed on both sides. Use binder clips to hold the pages together while you work.

2. Use a ruler to measure and an awl (or drill) to punch seven holes, each 0.5" (1.5cm) from the spine, top, and bottom edges.

3. Cut a 72" (183cm) length of thread. Begin at hole #2 (holes are numbered from RIGHT to LEFT). Pull thread up through hole #2 from BOTTOM to TOP. Wrap thread AROUND the spine, re-enter up hole #2, and pull snug.

4. Pull thread down through hole #1. Wrap thread around spine and back down through #1. Wrap thread around the short edge of the stack (to the right of #1) and back down through #1. Pull snug. Pull thread up through #2.

5. Pull thread down through #3. Wrap around spine and back down through #3.

6. Repeat, going up through #4, down #5, up #6, and down #7.

7. Wrap thread around the spine and back down through #7. Wrap around the short edge of the stack (to the left of #7) and back down through #7.

8. Pull thread through up #6, down #5, up #4, and down #3.

9. Tie a square knot. Cut off the excess.

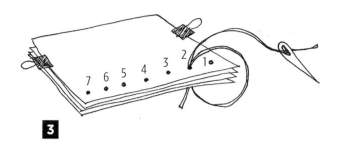

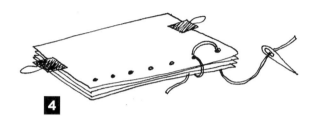

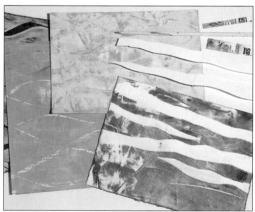

When printing, leave spaces on your papers for writing and journaling.

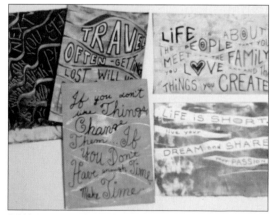

Add letters, words, and thoughts with colors of large paint pen markers.

Sample journal pages

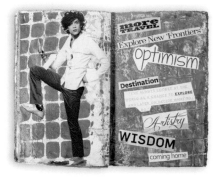

Just for Fun
I clipped inspiring words and an image from magazines. Is this person fenced in by life? He seems to be dancing anyway.

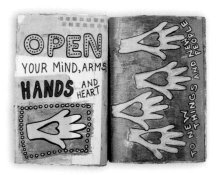

Open Your Mind
This page is a fun reminder that it's the people in my life that matter most. I traced around a hand stencil from Dreamweaver. The hands remind me of our grandbaby and my four children.

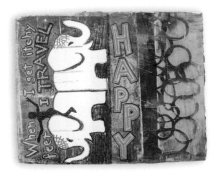

Travel
A trip to India was one of the highlights of my year. Traveling influences my art and journals because exposure to new places, people, and ideas feeds creativity and inspiration.

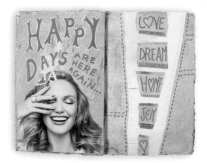

Happy Days
This smile is irresistible. I feel joy bursting from this page like rays of sunshine.

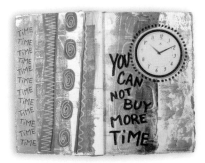

You Can't Buy More Time
I was inspired by the clock image and the saying "All we have to decide is what to do with the time that is given us," from J. R. R. Tolkien.

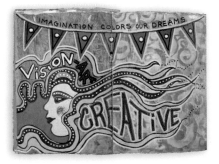

Vision Art
I'm playing around with images here. The figure is looking into the dark. Sometimes you have to look in another direction to see the light and find your happiness.

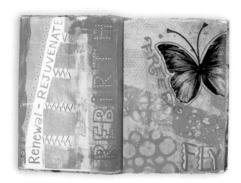

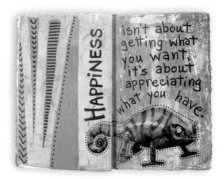

Blue Butterfly

Everyone who knows me knows that I identify with the freedom and renewal of the butterfly. It is a colorful design that I often include in my art.

Happiness

One of my favorite sentiments, "appreciate what you have," developed on this page because the greens and yellows in the background reminded me of my travels into the Amazon rainforest. The lines in the paper look like tree trunks—the perfect home for a chameleon critter.

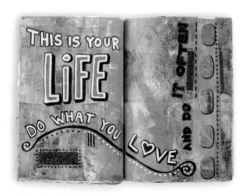

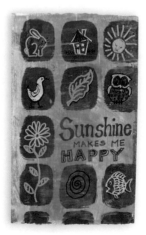

This is Your Life

When you use printed papers to make your journal, the background determines a lot about the page. Color sets the mood, and often the shapes set the theme. It's like walking onto a theater set that is just waiting for the actors. I challenge myself to incorporate background into the art itself.

Sunshine Makes Me Happy

Those wonderful red boxes printed on the paper inspired me to draw small images. They remind me of spaces in a shadowbox, begging to be filled.

Enhanced Paintings: Exploration of Color

BY PAULA RAYER NEMEC, BFA

A wonderful way to add these random textures and colors is by using a gel plate and acrylic paints like a giant stamp. Paula stands back to look with an imaginative eye to see an image emerge. To finish a painting, Paula adds, covers up, glazes colors, adds more textures with a gel plate, and brings out the image. Let Paula's art inspire you to stretch your vision and expand your horizons of what can be done with gel printing.

Paula consults and teaches creativity through painting and design. She lectures nationally on creative thinking, painting challenges, and the art of mastering the unknown. Paula is an artist whose work verges on the abstract with a touch of reality represented in her symbols, shapes, or figures. Paula paints an inner vision of the world around her. She delights in capturing the human condition, the life force that is within all of us, and the essence of what she perceives at that moment. Paula can be contacted through explorer@craigsearch.com.

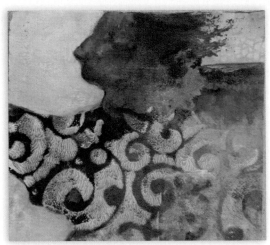

Tracking the Muse

12" x 12" (30.5 x 30.5cm) on 140# CP watercolor paper

This charming painting captures the feeling of freedom, the wind in your hair, and facing a future of endless possibilities. Paula laid in color and texture with acrylic paint. Features on the face were added and some highlights were stamped where needed. She used a gel plate and a stencil to create the textured pattern on the dress.

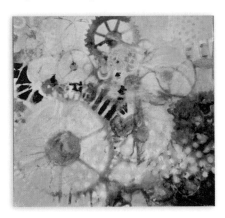

Oops, Great Gears

12" x 12" (30.5 x 30.5cm) on 140# CP watercolor paper

Paula's creative process embraces change: always moving, growing, and pushing in new directions. The stencil gears in this piece reflect both the complexity and the motion that trademark her art. What does your art say about you? Paula glazed random red, yellow, and orange acrylic color onto watercolor paper. She stamped squares and grids onto various places to add to the underpainting. Opaque colors were used to produce hard edges and define the gears.

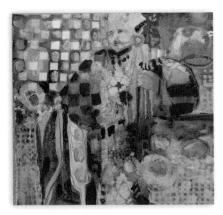

Sensei, the Mentor

12" x 12" (30.5 x 30.5cm) on 140# CP watercolor paper

Sensei, representing a teacher or mentor, appeared while Paula was working on this painting. She often begins a piece of art by applying random colors and textures to paper. Sensei was started with a checkered stencil laid over a painted 6" x 6" (15 x 15cm) gel plate. Then Paula glazed, spattered, defined, and stamped squares. The Sensei appeared at the top of the paper. A large body was defined with stronger red opaque color.

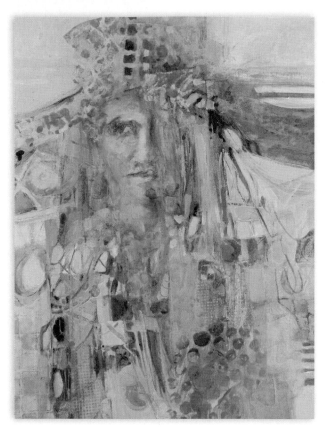

Woman of Symbols

22" x 30" (56 x 76cm) on 140# CP watercolor paper

Paintings are made up of a variety of symbols. Paula's symbols are a combination of her observations filtered through her thoughts and emotions. Sometimes they are very abstract, coming directly from her intuitive way of painting, and sometimes they are recognizable. All of Paula's works have many layers, expressing an appreciation for the miracle of life and the art of being fully involved in living it. For this piece, she randomly applied acrylic paint, then drew the figure. She used printed deli paper with the same bright colors to collage on the hat and placed a few pieces of the deli paper at the edges of the piece. To finish, she glazed over areas with a neutral blue and blocked in hard-edged shapes.

Gel-Printed Fabrics for a Pieced Quilt

BY JENNIE FRANZ

Jennie fell in love with gel printing as soon as she tried it. She loves to print her own fabric patterns and experiments with overprinting small fabric patterns to create wonderful textures. Her love is designing small pieced art quilts. In this sample, Jennie combined printed muslin fabrics and overprinted traditional fabrics to create a medley of colors and textures.

Jennie is an amazing and diverse artist. She attempts to react to the beauty of life and the complexity of human emotion through an exploration of imagery. Her vocabulary is one of line and space trying to achieve rhythm and movement. You can contact Jennie through her website, *jenniefranz.com*.

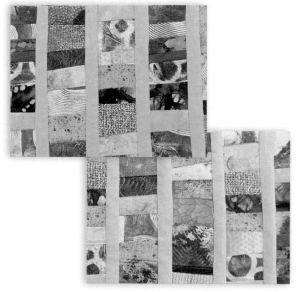

Collage Sculptures

BY PAULA PILLOW

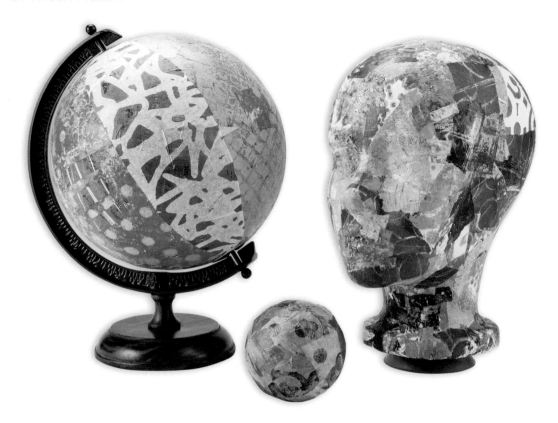

When looking at familiar objects in a new way, you open your perception to new ideas and new sources of creative energy. Try collaging printed deli papers over your favorite shapes and take your art in new directions.

MATERIALS: a shape to collage (papier mâché head, papier mâché ball, globe, etc.), assortment of printed deli papers, plastic card, adhesive acrylic medium (such as Soft Gel Gloss).

1. Tear pieces of printed deli paper into the desired shapes.
2. Cover an area on the collage shape with adhesive acrylic medium. Lay deli paper on top, then gently pat and rub until smooth. Remove excess medium. Let dry.
3. Repeat with additional pieces of printed deli paper.

Bird Collage Painting

BY PAULA PILLOW, BS

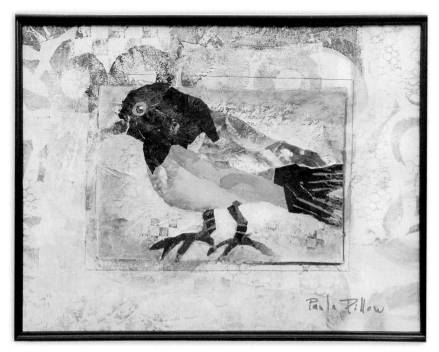

Collage printed deli papers to add layers of dimension, color, and interest to your painting. Try this technique to create something that is uniquely yours and artistically awesome.

Paula explores patterns, shapes, and textures using water media and fibers. Line and color capture an element of the unexpected, exploring a new way to view images.

MATERIALS: variety of printed deli papers, adhesive acrylic medium (such as Soft Gel Gloss), 15" x 22" (38 x 56cm) 140# CP watercolor paper for background, pencil, ruler, scissors.

1. Use a gel plate to print a series of designs and colors on deli paper.
2. Tear pieces of printed deli paper into the desired shapes. Adhere papers around the background with adhesive acrylic medium. Let dry.
3. Adhere an 8" x 12" (20.5 x 30.5cm) neutral paper to the center paper as a background. Let dry.
4. Draw a bird shape. Cut papers to fit each area of the bird. Create a collage by adhering papers to the background with adhesive acrylic medium.
5. Use paint to add a line shadow around the center block.

Glazing Over Black and Gray

BY SUZANNE MCNEILL

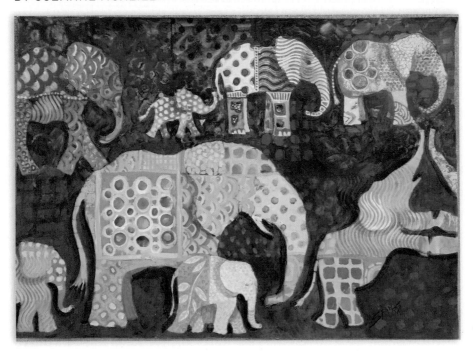

Elephant Walk

In India, elephants are decorated with paintings, jewelry, and sumptuous fabrics in exotic colors and patterns. This technique of glazing over gel prints captures the magic of an old tradition.

...

MATERIALS: 22" x 30" (56 x 76cm) 140# HP watercolor paper, transparent colors of fluid acrylics, gray, black, and white acrylic paint, colors of acrylic paint, assorted stencils, cardstock for elephant templates, pencil, paintbrush.

...

1. Roll out shades of gray paint onto a gel plate. Place a stencil over the paint. Using the plate as a stamp, pick up the plate, carefully turn the plate and stencil over, and press the plate onto the watercolor paper. Repeat until the paper is full of stenciled gray blocks. Let dry.
2. Draw elephants on cardstock and cut out to make templates. Place elephant templates on the stamped watercolor paper and trace around them with a pencil.
3. Brush each elephant with the desired transparent color. The print pattern will show through the color.
4. Fill in the background by brushing red and orange fluid acrylics over the print.
5. Highlight patterns with colors of acrylic paints.

Glazing Over Colors

BY SUZANNE MCNEILL

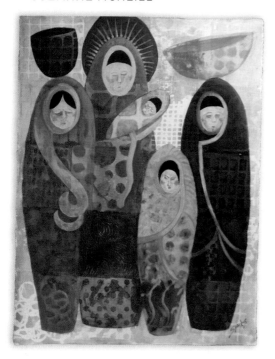

Women of the World

Figures are really fun to design, and these women offer an opportunity to experiment with expressions and color combinations.

·····

MATERIALS: 22" x 30" (56 x 76cm) 140# HP watercolor paper, transparent colors of fluid acrylics, colors of acrylic paint, assorted stencils, pencil, paintbrush.

·····

1. Roll out paint color onto a gel plate. Place a stencil over the paint. Using the plate as a stamp, pick up the plate, carefully turn the plate and stencil over, and press the plate onto watercolor paper. Repeat until the paper is full of tiled blocks. Let dry.
2. Draw women on the paper with a pencil.
3. Brush each woman with the desired transparent color. The print pattern will show through the glazes of color.
4. Paint the faces with opaque flesh color. Paint the hair black.
5. Fill in the background by glazing with white fluid acrylic.
6. Highlight patterns with colors of acrylic paints.

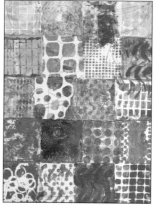

Print gel plate textures in a tiled pattern as you print them on a page.

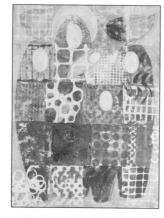

Glaze colors of fluid acrylics over the printed paper.

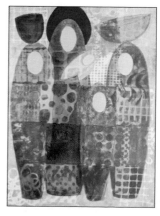

Repeat glazing to add depth and to darken the colors or lighten the background.

Beautiful Gift Wraps

Triangle Boxes

BY CAROLYN SKEI

EACH BOX: 2.5" x 2.5" x 2.5" (6.5 x 6.5 x 6.5cm)

These cute little containers are made of Carolyn's favorite things: found objects, fibers, and hand-printed papers.

MATERIALS: 7.5" x 10" (19 x 25.5cm) 140# CP watercolor paper, ruler, scissors, ribbon tie.

1. Use a gel plate to print your favorite colors and shapes. Let dry.
2. Fold the paper into four rows of 2.5" (6.5cm) wide each. Fold to make three columns of 2.5" (6.5cm) wide each. You will have a grid of twelve squares. Refer to the diagram to cut away two of the corner squares.
3. Punch a hole in the right flap for a closure. Make a tiny hole in the opposite block, thread a loop of ribbon through the tiny hole, and knot the loop secure on the inside of the box (the top of the paper, with the loop underneath on the outside of the box).
4. Pinch the center of both B blocks inward. Fold all C blocks inward on the diagonal.
5. Fold into a triangle-shaped box by overlapping the folded C blocks on the inside of the box. Tie ribbon around the base of the flap. Fold the flap down over the ribbon. Pass the ribbon loop you made in step 3 through the hole in the flap and secure with a twig.

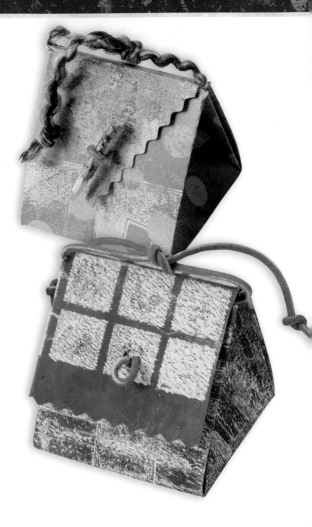

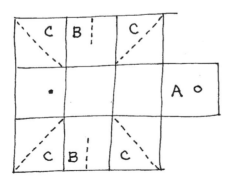

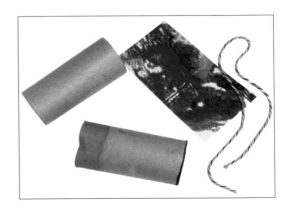

Colorful Gift Wraps

BY PAULA PILLOW

Create unique gift boxes that are so beautiful they will be used again and again. These fun boxes are also excellent storage for jewelry and small items.

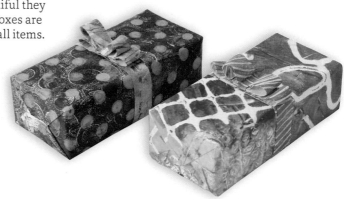

MATERIALS: small boxes, printed deli papers, ribbon, glue.

1. Wrap printed paper to cover a small box. Secure paper with tape.
2. Wrap with ribbon.

Tiny Pillow Gift Boxes

BY PAULA PILLOW

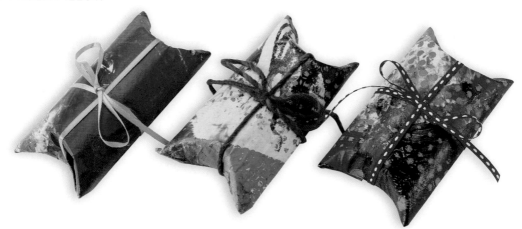

Turn bath tissue rolls into pretty little pillow boxes with this fun technique.

MATERIALS: bath tissue rolls, printed deli papers, ribbon, glue.

1. Wrap printed deli paper to cover a bath tissue roll.
2. Fold in the ends. Wrap with ribbon.

Colorful Tote Bags

BY CINDY SHEPARD

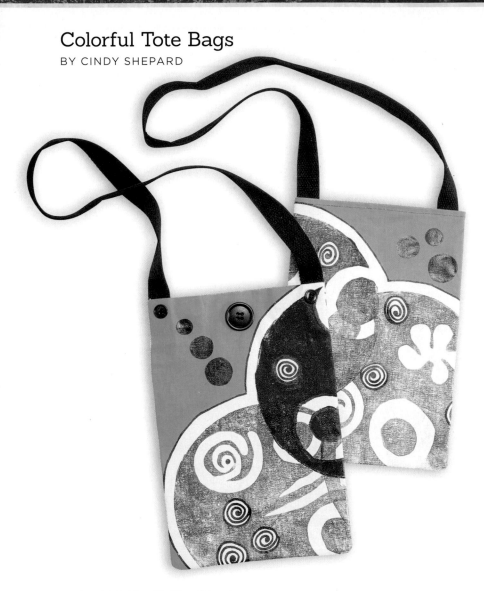

EACH BAG: 7" x 11" (18 x 28cm)

Stash your stuff in style! Tote bags are convenient for going out about town.
Cindy also uses them when gathering craft tools for a class—one tote for pens
and markers, another for rulers and drafting tools. You get the idea. Decide
what you want to store and make a tote to fit those items. It is a great way to
clean up your studio and keep items handy for use.

Cindy is an experimental artist with a focus on found objects, drawing,
painting, Zentangle®, mixed media, and jewelry. She has authored several
books and enjoys sharing her love for recycling and whimsy.

MATERIALS: 12" x 16" (30.5 x 40.5cm) canvas-paper, 30" (76cm) black 1" (2.5cm)-wide twill for handle, 2 black ⅝" (1.5cm) buttons for handle, 2" (5cm) fusible hook-and-loop tape for closure, sewing machine, thread, 8" (20.5cm) circle gel plate, scraps of Tyvek to make your own stencils, scissors, paintbrush, black paint marker, fluid acrylic paints in assorted colors, white and other colors of acrylic paint. Optional: assorted black buttons for decoration.

1. From Tyvek, cut out rings, funky flowers, wavy lines, spirals, and circles to use as masks.
2. Roll out fluid acrylic colors onto a gel plate. Place stencils onto the plate. Position a portion of the canvas-paper over the plate and press. Pull a print.
3. Repeat with other colors and stencils until you are happy with the design. Let dry.
4. Paint empty spaces with acrylic paint. Let dry.
5. Use a paint marker to draw swirls, to add decorative touches, and to draw solid circles in the background areas.
6. Use white acrylic paint to touch up any smears that occur. Let dry.
7. Pick a 16" (40.5cm) edge to be the top. Fold under a 0.25" (0.5cm) hem and topstitch. Fold the bag in half. Pin the handle ends 0.5" (1.5cm) from each side seam. Sew the handles in place.
8. Fold canvas-paper with right sides together. Sew around the remaining sides. Turn bag right side out. Optional: Place black buttons on the outside of the bag and sew in place by hand.
9. Position a 1" (2.5cm) piece of hook-and-loop tape to the inside top of the bag about 2" (5cm) from the side seam. Secure in place.

Heart Ornament

BY DENISE SPILLANE

Create papier mâché shapes for delightful gift tags and ornaments all year long.

MATERIALS: gel prints on deli paper, stencils, papier mâché hearts, matte medium, gel pens in black and white, white paint, paintbrush.

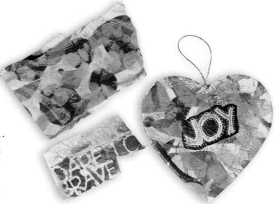

Paint the heart white and let it dry. Use a stencil to add words to the printed deli paper. Tear gel-printed paper into small, workable pieces and collage using matte medium. Make sure to wrap the edges and smooth the pieces to remove air bubbles. Let dry. Stencil words on deli paper. Use black and white gel pens to outline letters and add dots.

Abstract Collage Art

BY SUZANNE MCNEILL

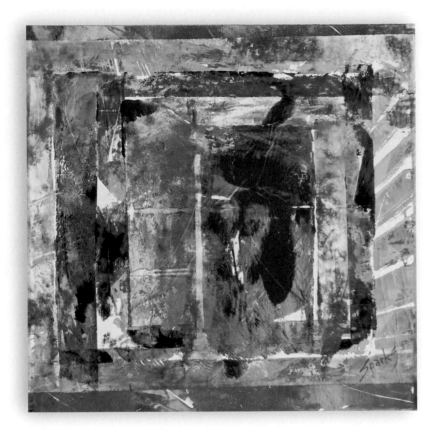

The real magic of this technique is that you can print a collection of colorful deli papers. Then choose your favorite printed deli paper and showcase it on canvas. Use only two deli paper prints to make this piece of art. Wrapping the edges extends the artwork.

MATERIALS: 12" x 12" (30.5 x 30.5cm) stretched canvas, 2 sheets 10" x 12" (25.5 x 30.5cm) printed deli paper, scissors, adhesive acrylic medium (such as Soft Gel Gloss), plastic card.

1. Roll out a patch of red onto a gel plate. Pull a print on deli paper.
2. Using the brayer technique (page 27), roll several stripes and borders in different colors. You don't have to let it dry between because the bit of bleeding you get at the edge is part of the desired effect. Let dry.
3. Roll out a solid color of paint onto deli paper. Let dry.
4. Spread adhesive acrylic medium onto canvas with a plastic card. Adhere printed deli paper to the center of the canvas.
5. Cut the solid deli paper into strips wide enough to cover the remaining canvas and to wrap around to the back. Adhere the strips. Let dry.

Geometrics

BY JOHN LANIER

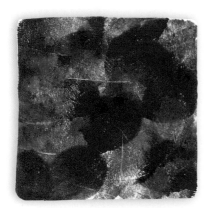
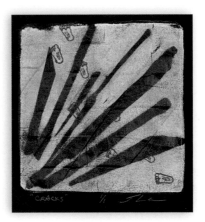
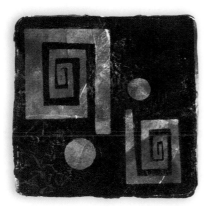
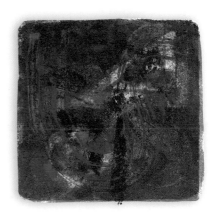

Create bold, graphic designs that will complement any modern home, office, or workspace. Turn your workplace cubicle into a gallery of inspiring art with simple printing techniques.

John had not done any artwork in over thirty years. Then he began to do some monoprints when he was introduced to the gel printing process. Using a gel plate with acrylic paints is so fast, and cleanup is a snap. John enjoys working with a variety of geometric stencils. Adding layers of colors for backgrounds is a joy. This process is great fun and has awakened the artist inside him.

MATERIALS: printmaking paper or 140# watercolor paper, acrylic paint, pencil, cardstock and/or objects for stencils, craft knife.

1. Cut stencils from the cardstock or decide on pleasing arrangements using your found objects.
2. Use multilayer and monoprint techniques to combine gel plate printing with stencils and masks.
3. Use iridescent paint to create radiance in the piece.

Equine Subjects

BY TERE GOLDSTEIN

This is a fun and seemingly simple process. It is fast, colorful, and opens up a world of possibilities for creativity. Tere loves the layering effect of building backgrounds and using stencils. The colorful, irregular edges are beautiful and lend to the immediacy and painterly quality that she likes in her work. Tere also uses this method to help work out ideas to begin a painting.

Tere's passion for horses led her to become a renowned equine artist. Now you can follow her lead and express your passion in prints that display your favorite animals and images that speak to you.

MATERIALS: printmaking paper or 140# watercolor paper, acrylic paint, pencil, cardstock for stencils, craft knife.

1. Draw horses or an image on cardstock. Cut out stencils with a craft knife. This gives both a positive and a negative for the stencils and masks.
2. Roll out paint onto a gel plate to create a background. Use stencils in some of the backgrounds.
3. Position stencils and roll over the stencils with a brayer. Let dry.
4. Add additional paint layers to the horses or images by laying a stencil over the image and adding another layer of paint with the brayer. Let dry.

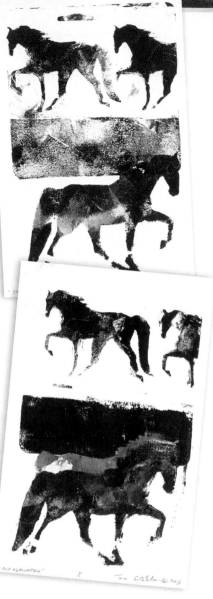

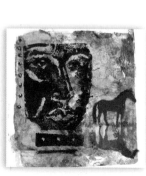

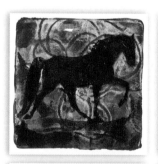
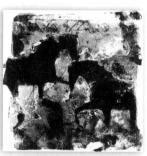

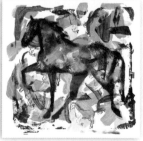
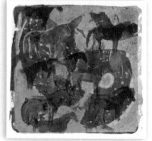

Sonata Quilt

BY CAROLYN SKEI

This mini quilt really is art inspired by nature. Make a collection of pressed leaves or flowers. Use this technique to incorporate those treasures into a quilted work of art.

Collage, fabric dyeing, fabric painting, quilting, bookbinding, and photography have interested Carolyn since childhood. Much of her work involves experimental processes—improvisation with fabric, fibers, paints, dyes, and digital imagery. Creativity is a necessity and a joy, and knowing others who draw sustenance from art genuinely excites Carolyn. Don't hesitate to contact her at *CarolynSkei.com.*

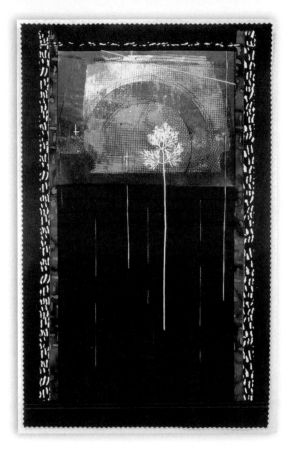

MATERIALS: acrylic paints, a pressed plant, printed fabric for borders, embroidery floss (white, gold, orange), chenille needle, sewing machine, thread.

1. Use a gel plate to print a background design on 6" x 10" (15 x 25.5cm) black fabric. Use iridescent colors.
2. Place a plant on freezer paper and roll white paint over it. Carefully pick up the plant and lay it on fabric. Press down to stamp the plant. Remove plant. Let the fabric dry.
3. Sew printed fabric to a 10" x 13" (25.5 x 33cm) piece of black fabric. Add borders of printed fabric until the piece measures 13" x 22" (33 x 56cm).
4. Layer backing, batting, and top. Free motion quilt with black thread. Embroider with white floss to make the stem and accent lines.
5. Finish the edge with pinking shears.

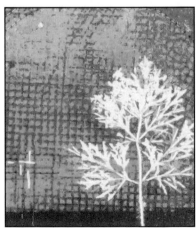

Greeting Cards

BY SUZANNE MCNEILL EXCEPT ABSTRACT
MINI ART BY PAULA PILLOW

EACH CARD: FOLDED TO 5" x 6.5" (12.5 x 16.5cm)

When you care enough, you make it yourself. Use your gel-printed papers to create cards that will be treasured as works of art. The image possibilities are endless and the opportunity to make someone you love smile is priceless. There are so many different ways to decorate and personalize cards! Here are a few ideas to fuel your imagination. I hope these cards will inspire you to create using gel plate prints.

1. Draw a head and arms (or a shape) on a card.
2. Place it on a light table.
3. Choose a printed paper.
4. Use a pencil to draw a dress or image.
5. Cut out the dress or shape.
6. Glue it to the card.

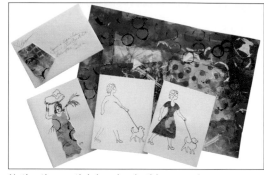

Notice the partial drawing in this example.

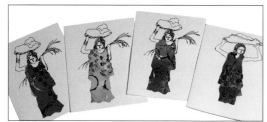

TIP: Create a series of cards using the same image decorated with different papers and colors.

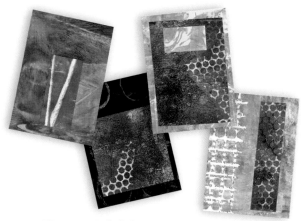

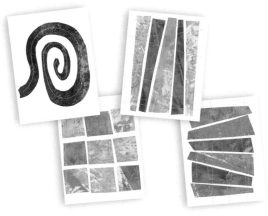

Abstract Mini Art

Small papers turn cards into mini abstract pieces of art. Share your time, creativity, and imagination by making a series of cards.

...

MATERIALS: scraps of printed papers, glue, pencil, scissors.

...

Arrange pieces of printed papers on a card. Glue in place.

Stitched Scraps

Don't throw away those tiny scraps! Some of these pieces are only 0.25" (0.5cm) wide.

...

MATERIALS: cardstock, scraps of printed papers, glue stick, sewing machine, thread.

...

Arrange scraps on the card in a pleasing manner. Lightly glue in place. Sew across the pieces to add another layer of texture.

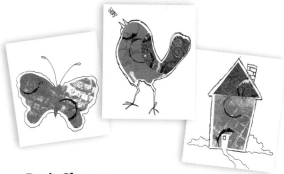

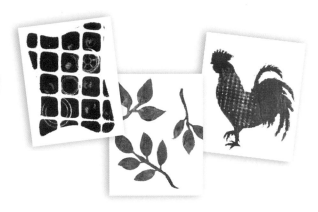

Basic Shapes

This technique is interesting because you only draw part of the image (in this case, the legs, bug, antennae, and outline).

..

MATERIALS: scraps of printed papers, glue, black permanent pen.

..

Draw the outline of your image. Add details. Cut out papers to form the shape inside the outline. Glue in place.

Gel-Printed Cards

Stencils are the fastest way to get a card done, so the next time you need a bunch of cards as soon as possible, use a gel plate and you'll be ready to go.

..

MATERIALS: stencil, acrylic paint.

..

Roll out paint on a gel plate. Place a stencil over the plate. Place a card over the stencil, press, and pull a print.

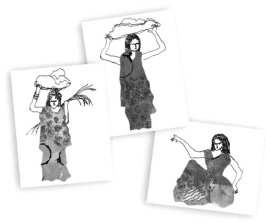

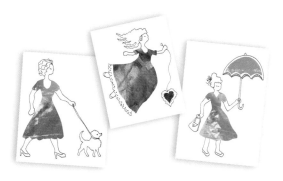

Women at Work

This is a free-form way of creating dresses for the figures. Start with a partial drawing and let your papers do the work.

..

MATERIALS: scraps of printed papers, glue, pencil, scissors, black permanent pen.

..

Draw an open design on the card. Draw parts of the dress on printed paper. Cut out the shape. Glue paper to the drawing.

Whimsical Ladies in Dresses

This technique is a lot of fun. It reminds me of dressing paper dolls when I was a child. Any open shape will work.

..

MATERIALS: cardstock, scraps of printed papers, glue, pencil, scissors, black permanent pen.

..

Draw an open design on the card. Draw parts of the dress on printed paper. Cut out the shape. Glue paper to the drawing.

Sunrise Quilt

BY SUZANNE MCNEILL

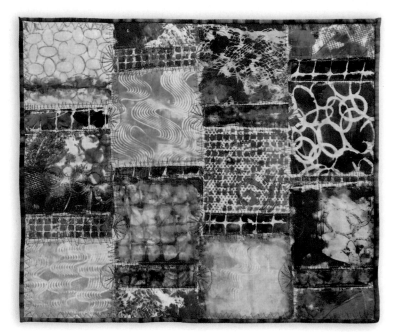

FINISHED SIZE: 18.5" x 21.5" (47 x 54.5cm)

Reds and golds capture the essence of a new day, full of vibrant energy, creative spirit, and joy.

..

MATERIALS: 1 yard (1m) cotton muslin for printing, 20" x 22" (51 x 56cm) cotton muslin for quilt top, fusible web, quilt batting, fabric for backing and binding, sewing machine, thread, an iron.

..

TIP: Print extra fabric so you can choose your favorite colors of fabric.

Follow the Basic Quilt Instructions on page 76.

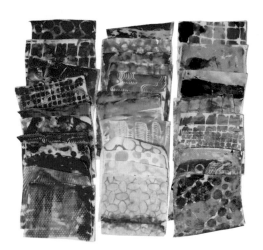

Fabric Art Journal

BY SUZANNE MCNEILL

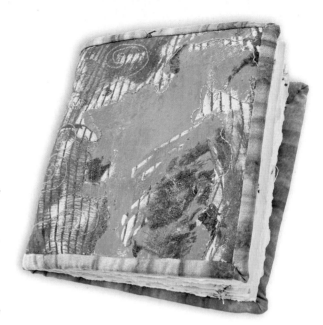

FINISHED SIZE: 5" x 5" (12.5 x 12.5cm)

Try printing on fabric to create a cover for a small art journal. This provides a wonderful opportunity to experiment on a small scale. This is also a great way to use leftover scraps of printed fabric.

..

MATERIALS: 6" x 12" (15 x 30.5cm) cotton muslin for printing, quilt batting, fabric for backing and binding, sewing machine, thread, an iron. For pages: 6 pieces 5" x 10" (12.5 x 25.5cm) 140# watercolor paper, awl to punch holes for binding, waxed linen thread, large eye needle.

..

1. Follow the Basic Quilt Instructions on page 76.
2. Trim to 5" x 10" (12.5 x 25.5cm). Add a 2.5" (6.5cm)-wide strip for binding.
3. To make the pages, cut or tear watercolor paper to size. For added interest, use a sewing machine to couch yarn across each page.
4. Fold all pages in half to find the center. Bind pages together with a Pamphlet Stitch (see page 53).

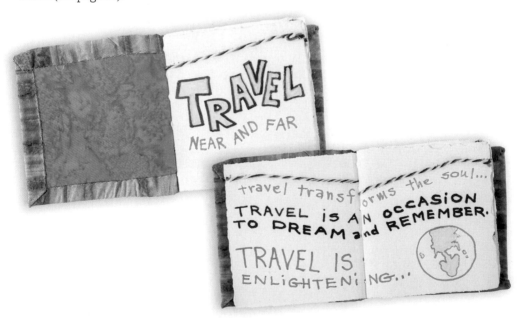

Quilted Carry-All Bags

BY SUZANNE MCNEILL

Carry-all quilted bags are fashionable and helpful. They securely zip shut. Quilted bags are easy to make and fun to use.

MATERIALS: cotton muslin for quilt top and for printing, fusible web, printed fabric for backing and binding, quilt batting, sewing machine, thread, an iron, a separating zipper.

TIP: Print extra fabric so you can choose your favorite colors of fabric.

Follow the Basic Quilt Instructions below.

Basic Quilt Instructions

1. Press fusible web to the back of cotton muslin, following the manufacturer's instructions.
2. Cut pieces to fit a gel plate. Use a variety of printing techniques to create prints in coordinating colors like blues, yellows, reds, and oranges. Print fabrics and let dry.
3. Cut fabric pieces to desired size and fuse to a large muslin quilt top. Optional: Cut additional appliqué shapes and fuse on top of the quilt.
4. Layer backing, batting, and quilt top.
5. Use your sewing machine to free motion quilt. Be sure to go around the edge of each piece.
6. Sew a 2.5" (6.5cm)-wide strip for binding to the front. Turn the edge under. Hand stitch the binding.

Basic Handle Instructions

Fold a 2.5" (6.5cm)-wide strip of fabric (fused to quilt batting) in half lengthwise to make a piece that is 1.25" (3.2cm) wide. Sew a seam and turn the tube right side out. Press flat. Topstitch 0.25" (0.5cm) from each edge. Position each handle. Stitch in place.

Basic Zipper Instructions

Position and pin one side of the zipper on one top edge. Topstitch the zipper in place. Repeat to attach the other side. Join and zip.

Finish the Bag

Fold the bag in half. Topstitch down each side next to the binding.

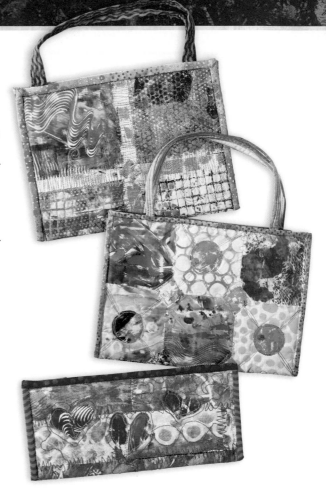

Large Carry-All Bag

This bag is the perfect size for carrying a sketchbook, pens, markers, and pencils with you everywhere you go. Printed fabrics show off your artistic talents even before you open your bag.

Finished size is 10" x 14" (25.5 x 35.5cm).

Medium Carry-All Bag

Like shoes, we all need an assortment of bags. Keep your stuff safely organized in this simple-to-construct tote.

Finished size is 8" x 11" (20.5 x 28cm).

Small Zippered Clutch

Next time you need a new mini bag, save money and express your creativity at the same time. It takes so little fabric, you'll be able to make one for a friend.

Finished size is 4.5" x 9.5" (11.5 x 24cm).

Safari Quilt

BY SUZANNE MCNEILL

FINISHED SIZE: 17" x 35" (43 x 89cm)

Animals often turn up in my art. The circle print is perfect for a giraffe and spotted deer. A wavy stripe is perfect for a zebra, and rhinos have scaly hides, so the print with the tiny squares was just right. The elephant looks like he is wearing a large blanket.

..

MATERIALS: 2 yards (2m) muslin, fusible web, 1 yard (1m) cotton print for backing and binding, quilt batting, yarn for details, sewing machine, thread, scissors, an iron.

..

Arrange green printed squares and piece them together to make a background 18" x 36" (45.5 x 91.5cm). Draw animals on the paper covering of fusible web, cut out, peel off paper, and fuse in place. Follow Basic Quilt Instructions (page 76). Couch yarn around animals.

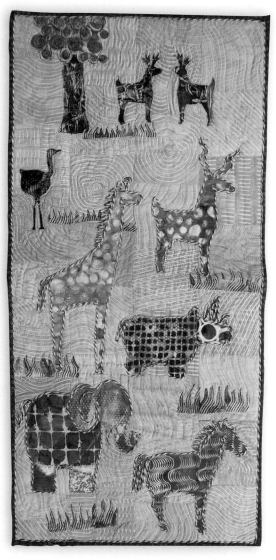

Close-up of stitching and couched yarn

Cityscape at Sunset Quilt

BY SUZANNE MCNEILL

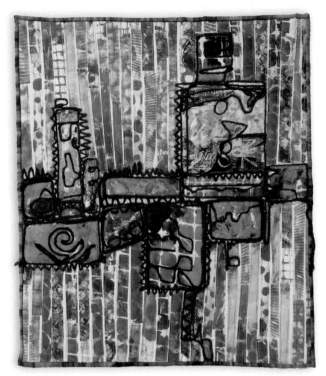

Close-up of the couching accents

FINISHED SIZE: 18" x 21" (45.5 x 53.5cm)

Sometimes colors speak to me and determine what kind of project they will be. My orange collection of scraps became the sunset, while the blue prints became buildings. I outlined and added accents with yarn to add both texture and definition.

MATERIALS: 2 yards (2m) muslin, fusible web, 1 yard (1m) cotton print for backing and binding, quilt batting, yarn for details, sewing machine, thread, scissors, an iron.

Follow the Basic Quilt Instructions (page 76). Finish by free motion couching yarn on all blue pieces.

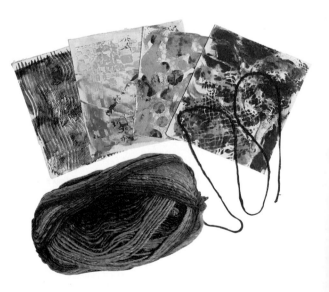

Party Dogs Art: Chewy and Rascal

BY BRENDA WYATT

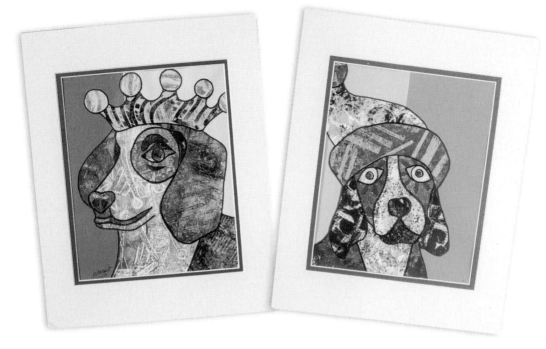

EACH PIECE: 8" x 10" (20.5 x 25.5cm)

Brenda's very creative friend Carolyn Skei recently introduced her to gel printing in a workshop. To contribute artwork for a local Humane Society auction, Brenda made sketches of her dogs. A photo of her dog Rascal in a Santa hat inspired her to create a series called "Party Dogs." The whimsical cartoon look of these framed pieces resulted in a bidding war at the auction. Brenda then did a whole series of these wonderful creatures, as all her friends sent photos of their animals to her for their own portraits.

Brenda is a member of the Dallas Area Fiber Artists and the Chair of the Keller Public Arts Board. She is a retired art teacher. "I have had a love of printmaking since college, more recently experimenting with Photopolymer Intaglio and relief prints. I found gel plate printing very addicting and began to fill my studio with experimentation. I like printing on thin deli papers, telephone books, old patterns, and rice papers." You can contact Brenda at brenwyatt@aol.com.

MATERIALS: collection of printed deli papers, 8" x 10" (20.5 x 25.5cm) matboard for backing, wide black permanent marker, heavy clear vinyl for making template, adhesive acrylic medium (such as Soft Gel Gloss), solid color cardstock, scissors, a mat and frame.

1. Sketch an animal until you get the expression you like. You can enlarge a photograph if that helps you.
2. Trace over the sketches on vinyl using a permanent marker.
3. Cut out the pieces, creating clear plastic templates. The clear templates allow you to find just the right piece for each part of the animals in your collection of printed deli papers.
4. Cut out the pieces from printed deli papers. Adhere pieces to matboard. Let dry.
5. Outline the edges with a black marker.
6. Mat and frame as desired.

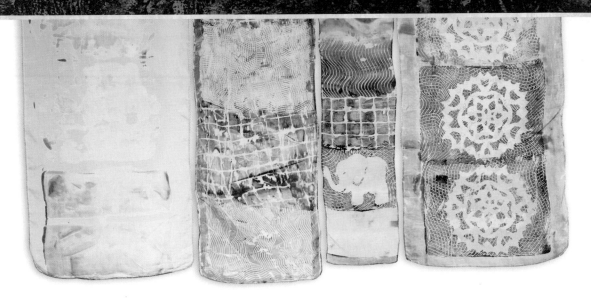

Silk Scarves

BY SUZANNE MCNEILL

FINISHED SIZE: 11" x 60" (28 x 153cm) OR 15" x 60" (38 x 153cm); MADE WITH HABOTAI SILK

Silk is a sumptuous fabric. It is luxurious against your skin, and printed silk is classy. Silk accepts paints with ease, allowing the creation of absolutely gorgeous patterns in fabulous colors. These scarves were printed using gel plates with various techniques.

MATERIALS: fabric painting medium (such as GAC 900), transparent colors of fluid acrylics, brayer, stencils, assorted textures.

TIP: The sample scarf was printed with a 6" x 6" (15 x 15cm) gel plate in a tiled pattern.

Printing, Block 1

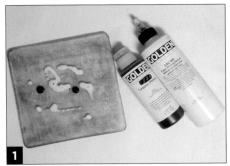

1

Lightly drip the fabric painting medium and a couple drops of fluid acrylic onto the plate.

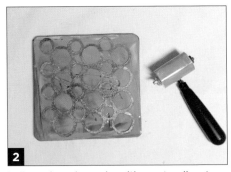

2

Roll out the color and position a stencil on top.

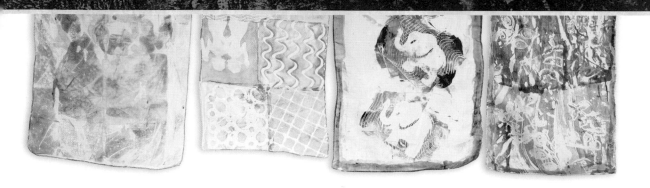

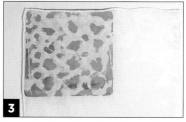

3 Carefully align the edge of a scarf with the edge of the plate.

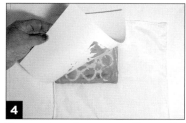

4 Place a piece of paper over the scarf. Gently press. Lift the paper. Some of the paint will bleed through the scarf onto the paper.

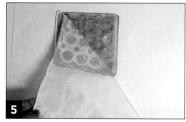

5 Gently lift the scarf and set it aside to dry.

Printing, Block 2

6 Do not clean the gel plate. Just add a little more fabric painting medium and a couple drops of a second color of fluid acrylic.

7 Roll out the color. Lay a stencil in place.

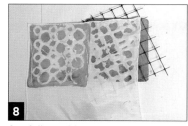

8 Carefully position the scarf so the edge aligns with the edge of the first block. Lay a piece of paper over the scarf as before. Press.

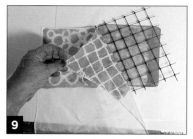

9 Gently lift the scarf and set it aside to dry.

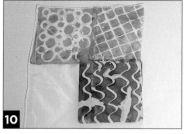

10 Continue printing blocks of color and texture until the scarf is finished. Let dry.

T-Shirts

BY SUZANNE MCNEILL

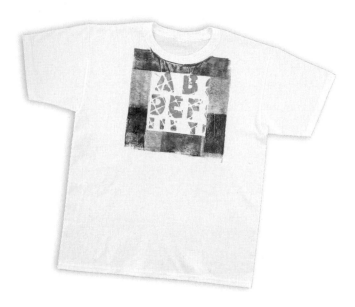

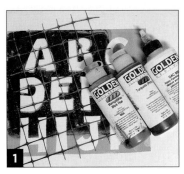

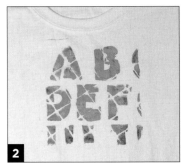

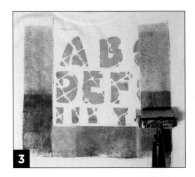

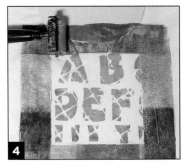

Why wear a plain old tee when you can jazz it up with anything from a rooster to an alphabet to a texture?

MATERIALS: fabric painting medium (such as GAC 900), fluid acrylic paints, brayer, stencils, assorted textures.

1. Drizzle the fabric painting medium and a few drops of fluid acrylic onto the gel plate. Roll out with a brayer. Lay a stencil and a texture on top.
2. Place a piece of freezer paper inside the shirt, with the shiny side next to the plate. Very carefully position the shirt on top of the plate. Press to make the paint print on the shirt. Lift off the shirt.
3. Drizzle the fabric painting medium and a few drops of fluid acrylic onto freezer paper. Roll out paint with the brayer. Carefully roll the brayer on the shirt to make three sides of the frame.
4. Cut a cardboard mask to fit over the neck edging and position it on the shirt. Carefully roll the brayer across the shirt, making the top border. Remove the mask. Let dry. Iron to heat set.

Connections Stitched Quilt

BY LIZ KETTLE

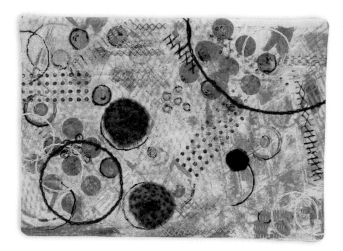

Close-up of stitching

FINISHED SIZE: 12" x 16" (30.5 x 40.5cm); 8" x 11" (20.5 x 28cm) IN THE CENTER

Many times inspiration is as simple as the fabric Liz has created. Liz loves the graphic shapes and the repetition on this piece of fabric. It begged for stitching. She did not start with any preconceived idea of what the stitching would look like before she began. She let the printing lead her on a journey.

Liz is a mixed media and textile artist living in Colorado. She is author of *First Time Beading on Fabric* and co-author of two more books: *Fabric Embellishing: The Basics and Beyond* and *Threads: The Basics and Beyond.* Liz loves teaching and sharing the joy of making handmade art in her articles, classes, and workshops. Visit her blog and website where you can join the fun in her free online book studies at *TextileEvolution.com.*

MATERIALS: gel-printed fabric, sheer fabric, fusible web, quilt batting, embroidery threads, chenille needle, thread, scissors.

1. Begin with fabric printed with a gel plate. Add a few sheer fabric circles to add interest to the basic design. You could add any type of fabric, such as silk, cotton, or even velvet.
2. Use a fusible web to fuse the printed fabric to thin quilt batting.
3. Choose your favorite embroidery threads to stitch on the surface. Liz approaches her hand stitching in a free-form manner. Sometimes the stitches are regular and even and other times she purposely stitches them wonky and irregular. Liz uses simple stitches such as the running stitch, cross stitch, and chain stitch. Try a combination of tonal threads to add texture and contrasting threads to help move the eye across the fabric.
4. After the stitching is finished, sew the embroidered fabric to a larger piece of fabric. Wrap quilt around a stretched canvas and secure with staples on the back.

TIP: When working with monoprinting on fabric that you would like to stitch heavily, use a textile paint or add a fabric painting medium (such as GAC 900) to regular acrylic paint. This will keep the hand of the fabric soft and easy to stitch.

Printed Totes

BY LIZ KETTLE

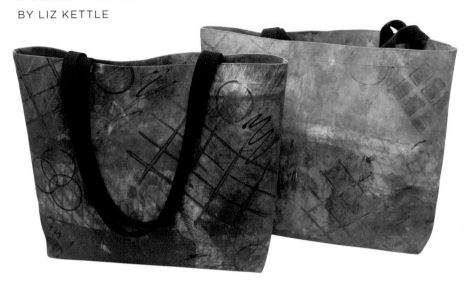

FINISHED SIZE: 12.5" TALL x 13" WIDE x 3.75" DEEP (32 x 33 x 9.5cm)

Liz loves tote bags and never seems to have enough! These bags are made from multi-purpose cloth (MPC), which is a non-woven canvas that monoprints like a dream. It is an amazing, sturdy canvas that does not have a distinct weave and doesn't fray. MPC is a favorite fabric for monoprinting. This bag is easily sized up or down depending on your needs.

...

MATERIALS (1 BAG): 17" x 30" (43 x 76cm) multi-purpose cloth, 2 pieces belt webbing (each 25" [63.5cm] long) for handles, acrylic paint, sewing machine, thread.

...

1. Print the fabric with a gel plate. The MPC absorbs the paint quickly, so you don't have to wait long to add more layers. You can monoprint both sides of the canvas if desired.
2. After the piece is dry, fold the fabric in half with right sides together to measure 15" x 17" (38 x 43cm).
3. Stitch along the 15" (38cm) sides to create the basic bag.
4. Create a gusset in the bottom of the bag by laying the bag flat on the table with one side seam running up the middle of the fabric.

Sewing the gusset

This will create a triangle at the bottom edge. Measure down 2"–2.5" (5–6.5cm) from the tip of the triangle and draw a straight line across the fabric. Stitch along this line. Trim the excess triangle from the bottom edge. Repeat for the other side.

5. To finish the top edge, fold down 1" (2.5cm) and press to the inside of the tote. Topstitch along both the top and bottom edges.
6. Place the handles 4.5" (11.5cm) from each side seam. Pin in place and stitch.
7. Turn the bag right side out and you are ready to go!

Paper Fabric Clutch

BY PAULA PILLOW

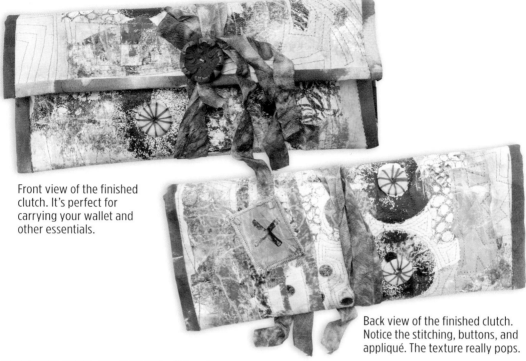

Front view of the finished clutch. It's perfect for carrying your wallet and other essentials.

Back view of the finished clutch. Notice the stitching, buttons, and appliqué. The texture really pops.

FINISHED SIZE: 4" x 9.5" (10 x 24cm)

Turn small scraps of printed deli paper, unusual buttons, and bits of ribbon and fabric into a beautifully unique clutch. It would be a wonderful birthday gift. All your friends will want one.

MATERIALS: collection of gel prints on deli paper, 2 pieces 10" x 10" (25.5 x 25.5cm) muslin, 10" x 10" (25.5 x 25.5cm) fabric for lining, lightweight batting, fabric for binding, sewing machine, thread.

1. Brush diluted white glue on one piece of muslin. Place torn pieces of deli paper into the wet glue. Brush diluted glue on top as you collage the pieces and cover the muslin. If desired, add diluted colors of acrylic paint while glue is still wet.
2. Let dry completely before cutting and stitching.
3. Layer the paper fabric, batting, and backing muslin. Free motion machine stitch the layers together, then add stitching and details as desired.
4. Add embellishment and hand stitching.
5. Add a lining fabric and bind the edges.
6. Fold the piece in half with extra at the top for a flap. Topstitch the sides. Fold the flap over. Add an antique button and ribbons to create a ribbon-wrapped closure.

Sketchbook Journals

BY DENISE SPILLANE

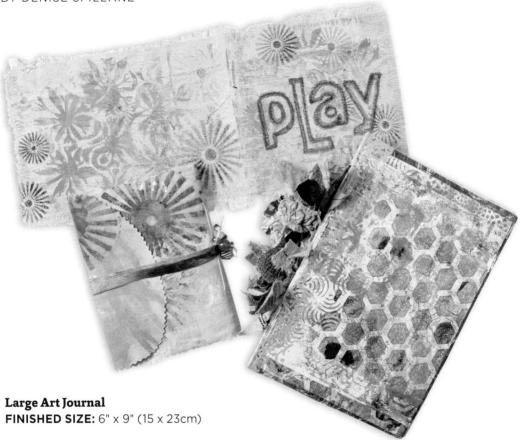

Large Art Journal
FINISHED SIZE: 6" x 9" (15 x 23cm)

Small Sketchbook
FINISHED SIZE: 5" x 6.5" (12.5 x 16.5cm)

Sketchbooks and art journals are perfect for collecting your beautiful gel-printed papers all in one place. Use your collection of papers to make notes, to sketch, and for inspiring collage and quotes. Sew the pages together with a Pamphlet Stitch (see page 53).

Denise is the Chair of Mini Workshops at Dallas Area Fiber Artists. It is Denise's goal to share with her friends and to inspire you to try many different techniques. To learn more about her art and workshops, contact her at sunmoongal@me.com.

MATERIALS: a book cover, 30 gel prints on 90# mixed media 8" x 10" (20.5 x 25.5cm) paper, waxed linen thread, large eye needle, awl, 1" x 3" (2.5 x 7.5cm) fabric strips to tie around the binding threads.

Words, thoughts, and doodles fill the spaces in the stenciled leaf.

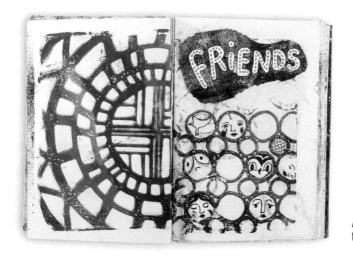

Add a title and draw little faces in the stenciled circles.

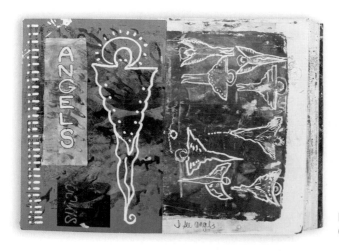

Denise filled a page with charming doodle drawings of angels.

Index

Note: Page numbers in *italics* indicate projects.